IMAGES
of Aviation

AVIATION IN TULSA AND NORTHEAST OKLAHOMA

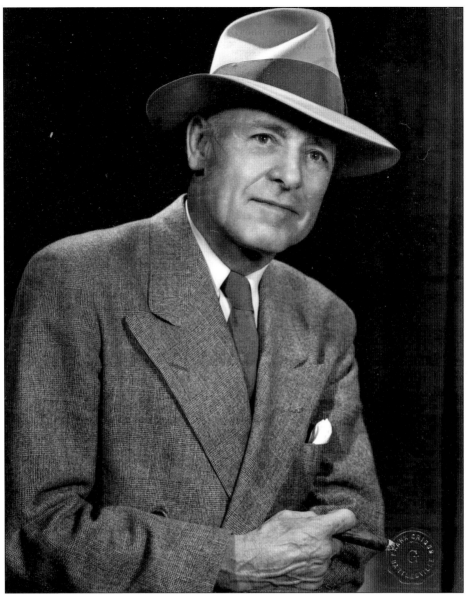

Charles W. (Charlie) Short was chosen by oilman W. G. Skelly as the manager to help get Tulsa Municipal Airport ready for its opening day and the arrival of the Ford Reliability Tour on July 3, 1928. Short is the reason for many of the wonderful photographs in this book. He took photographs of many of the aviation greats that visited Tulsa Municipal Airport during his 27-year reign. (Tulsa Air and Space Museum, courtesy Tulsa Airport Authority.)

On the cover: Please see page 72. (Tulsa Air and Space Museum, courtesy Boeing Company.)

IMAGES
of Aviation

AVIATION IN TULSA AND NORTHEAST OKLAHOMA

Kim Jones

ARCADIA
PUBLISHING

Published by Arcadia Publishing
Charleston SC, Chicago IL, Portsmouth NH, San Francisco CA

Printed in the United States of America

Library of Congress Catalog Card Number: 2008925384

For all general information contact Arcadia Publishing at:
Telephone 843-853-2070
Fax 843-853-0044
E-mail sales@arcadiapublishing.com
For customer service and orders:
Toll-Free 1-888-313-2665

Visit us on the Internet at www.arcadiapublishing.com

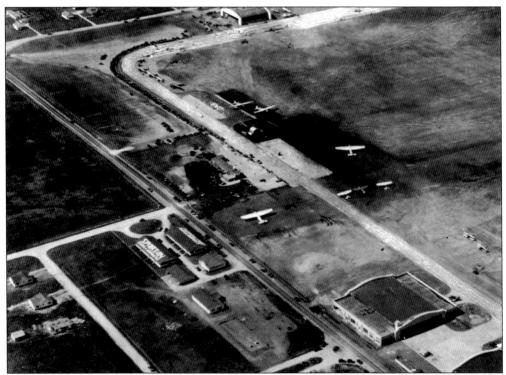

Here is Tulsa Municipal Airport in 1929, showing the original wood and tar paper shack that served as the terminal for the first four years of its existence. In the foreground is Spartan School of Aeronautics, and in the background is the famous Hangar 1 that played host to the aircraft of aviation greats such as Amelia Earhart, Wiley Post, Jimmy Doolittle, and Charles Lindbergh. (Tulsa Air and Space Museum.)

CONTENTS

ACKNOWLEDGMENTS

It is an honor to be able to tell this story that so many Tulsans and Oklahomans have had a hand in creating. The photographs of Tulsa Airport Authority's collection, including the Charlie Short collection, allow a glimpse into the past that could never be envisioned otherwise. The individuals I have had the pleasure to work with through the years at the Tulsa Airport Authority who deserve special thanks start with Nancy McNair for taking care of the legal work that allowed me to share these photographs with the public. Imogene Arnot, Jan Mauritson, and Debra Coughlan guarded the airport's collection from being dispersed to the four winds after the passing of Short in 1955. Alexis Higgins was an advocate for housing the collection in the Tulsa Air and Space Museum (TASM) archives where it would be cataloged and preserved for future generations. The board of directors, staff, and volunteers of the Tulsa Air and Space Museum and Planetarium deserve many thanks for the job they do in keeping history alive and chronicling the incredible aviation heritage of the Tulsa area. Katheryn Pennington, executive director of TASM, allowed me to work on this book on "company time" so that it would be completed in a timely manner. Kevin Gray, whom I often refer to as the "history ferret" for his talent of rooting out great stories from Tulsa's aviation past, helped gather photographs when I simply did not have the time. Thanks go to all the people who have donated their photographs and artifacts to TASM over the last 10 years so that the story can be told. Ted Gerstle, my editor at Arcadia Publishing, deserves thanks for his help and guidance and making that fateful telephone call asking, "Would you know of anyone that would be interested in writing a book on Tulsa aviation?" Finally, I would like to thank my wife, Loretta, for doing without me at times during the move into our new home and for helping with my other museum work, which allowed me the time to complete this book. I love and appreciate you.

INTRODUCTION

Tulsa and the surrounding area have been enthralled with aviation since the very beginning of manned flight. Tulsa's first aviation event was a smoke-balloon ascension at the 1897 Independence Day celebration. The small ranching town of 5,000 was smitten and welcomed the daring aeronaut back five years later, again for the Fourth of July picnic. When the Wright brothers successfully flew their creation in 1903, people were looking to powered, controllable flight rather than drifting with the wind. In Tulsa, a young inventor named Jimmie Jones tried his hand at building an airplane in 1906. While it never flew, blowing away in one of Oklahoma's famous thunderstorms, it was a portent of things to come for the young cow town. Oil was soon discovered in the area, and the oilmen were some of the first to see the utility of aviation. They realized that airplanes could be used to fly a new drill bit to a site when a rig went down. In the off times, they used their aircraft to fly sightseers around the area for $25 per flight. After World War I, local servicemen returned to Tulsa with an eye toward the sky. Aviator Duncan McIntyre, the undisputed "father of Tulsa aviation," came to Tulsa in 1919 to visit an old army buddy. Once he saw the aviation potential in Tulsa, he stayed to find his fortune. Operating McIntyre Airport, he hosted many early aviators, including Charles Lindbergh, Art Goebel, and the Ford Reliability Tour in 1927. Also arriving in Tulsa in 1919 was W. G. Skelly. Seeking his fortune in oil, he soon formed the Skelly Oil Company. By the mid-1920s, he became interested in aviation and its potential for the petroleum industry. Skelly heard about Willis Brown, who was manufacturing an airplane of his own design in downtown Tulsa. Brown called it the Spartan C-3, but the locals called it the brown mule. Skelly arranged to see the airplane and was so impressed that he bought the company and hired Brown to run it. This soon began the Spartan Aircraft Company, best known for its Spartan Model 7-W Executive aircraft. Another oilman, Robert Garland, built an airport complete with hangars and classrooms and, by 1929, was operating the Garland-Clevenger School of Aeronautics in Tulsa.

With the arrival of the Ford Reliability Tour and Lindbergh at McIntyre Airport in 1927, the city fathers were admonished that they should really build a city-owned airport for Tulsa or they would never be anything but a spur on the mail route. With these urgings, the chamber of commerce created an aviation committee. With the help of Skelly, the committee began a secret search for land on which to build an airport. Beginning with 490 acres, Tulsa Municipal Airport was opened on July 3, 1928, with the arrival of the 1928 Ford Reliability Tour. Skelly located his Spartan Aircraft Company in a new building just one mile south of the new airport. By 1930, Tulsa Municipal Airport was purported to be the busiest airport in the world due to the oil boom. Anyone that was anyone in aviation came through Tulsa, including Jimmy Doolittle,

Amelia Earhart, Frank Hawks, Will Rogers, Wiley Post, Harold Gatty, and Charles and Anne Morrow Lindbergh, to name a few.

Tulsa was in the thick of aviation. By 1932, a new art deco terminal building was constructed. Skelly began his Spartan School of Aeronautics shortly after the opening of the airport. With training facilities and manufacturing underway, Tulsa was beginning to be noticed around the country. As war clouds gathered in Europe, Pres. Franklin D. Roosevelt was creating the Arsenal of Democracy, and Tulsa was soon to be the recipient of air force plant No. 3. Ground was broken in March 1941, and it was revealed that Donald Douglas would operate the plant in Tulsa. Spartan School was contacted about training British pilots in Tulsa, but due to inadequate facilities, it was decided that the British Flying Training School No. 3 would be located in Miami and operated by Spartan. During World War II, Douglas Tulsa built A-24 Banshees, B-24 Liberators, and A-26 Invaders. The Douglas modification center was constructed adjacent to plant No. 3, and thousands of aircraft were sent to Tulsa for modification during the war.

During the Korean War, Douglas Tulsa built B-47s and B-66s. During the Vietnam War, the plant modified and maintained thousands of military aircraft, including B-52s, F-4 Phantoms, A-1 Skyraiders, and A-4 Skyhawks. After the Soviet Union launched Sputnik, Douglas Tulsa was contacted by the newly created NASA to help it put something in orbit quick. By adding a second and third stage to the Thor ICBM (intercontinental ballistic missile), Douglas Tulsa created the Delta rocket, one of the most successful rocket programs ever.

Under the North American Aviation and Rockwell International banners, Tulsans built nearly 50 percent of the external structure of the Saturn V rockets that took America to the moon as well as much of the ground support equipment for the program. All the cargo bay doors for the shuttle program were built in Tulsa; when *Challenger* and *Columbia* were lost in two tragic accidents, a small piece of Tulsa went with them. Stealth technologies were pioneered in Tulsa during the navy's A-12 Avenger program, which was cancelled. Much of the work done in Tulsa was later used in other stealth programs.

As the aviation and aerospace giants such as McDonnell, Douglas, and Rockwell International merged, morphed, and were eventually absorbed by the Boeing Company, a new name was applied to air force plant No. 3. Just as these machinations were occurring, McDonnell Douglas procured a contract to help save the air force's C-17 Globemaster III program. From this, the Tulsa C-17 modification center was created, and the program continued for five years. Most recently, huge portions of the International Space Station were constructed in Tulsa under the Boeing logo.

Today the legacy continues as large subassemblies are being built by Spirit Aerosystems for Boeing's 787 Dreamliner. American Airlines has expanded its facility, creating the largest airline maintenance base in the world. On July 10, 2008, ground was broken for a new American Airlines 18,000-square-foot hangar at Tulsa International Airport that will allow the company to maintain the heavy airliners of the future. With over 300 aerospace businesses in the Tulsa area providing parts and services to the industry, aviation and aerospace will be the economic engine that propels Tulsa and northeast Oklahoma through the 21st century and beyond.

One

TINKERERS, OILMEN, AND ENTREPRENEURS

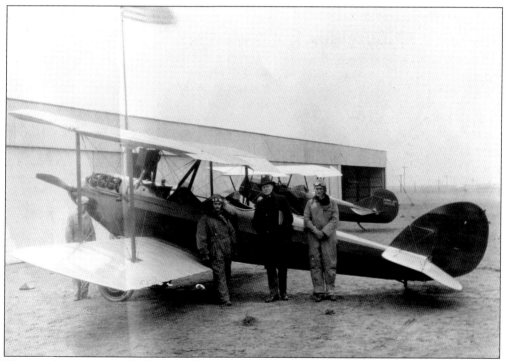

The man known as the "father of Tulsa aviation" was Duncan McIntyre. Although born in New Zealand, McIntyre came to Tulsa in 1919 to look up an old army buddy. They began buying war surplus Jennys from the government for $400, assembling them, and selling them for $1,200. The diminutive McIntyre bought out his partner and is shown here leaning against the wing of one of his Waco biplanes. (TASM, courtesy Margaret McIntyre.)

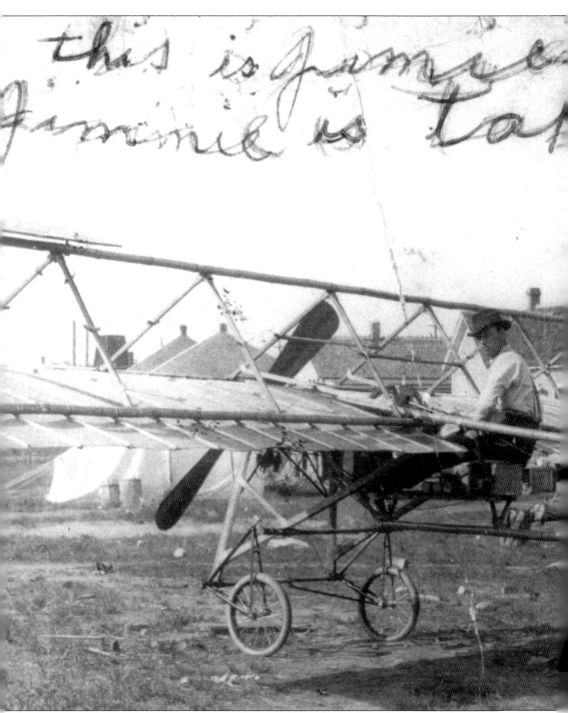

Only three short years after the Wright brothers made their successful first flight, a young Tulsa inventor named Jimmie Jones built an airplane of his own design. With the help of his friend Bill Stringler, Jones constructed the ship in his backyard in West Tulsa. Once it was completed, it occurred to Jones that he was an inventor not a pilot. He decided to disassemble the airplane and take it down near the Arkansas River to fly it, rightly thinking that the sand or water

would be softer than the West Tulsa clay should he crash. They hauled it to the river in a horse-drawn wagon and began to reassemble it. As the hot summer day progressed, the famous Oklahoma winds began to rise, so they decided to leave it until the following morning. During the night, a thunderstorm blew through and destroyed the aircraft completely. (TASM, courtesy Bill Strong.)

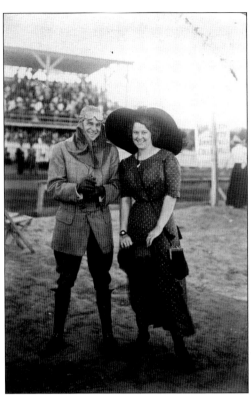

In 1911, aviator Leonard Bonney was engaged to fly for the Tulsa Fair. This image shows him and his wife standing in front of the grandstands at the fairgrounds in downtown Tulsa. A drawing was held among the local newspapermen to see who would be the first passenger to fly in Tulsa. The drawing was won by the editor of the *Tulsa World*, Eugene Lorton. Rumor had it that the drawing was rigged. (TASM.)

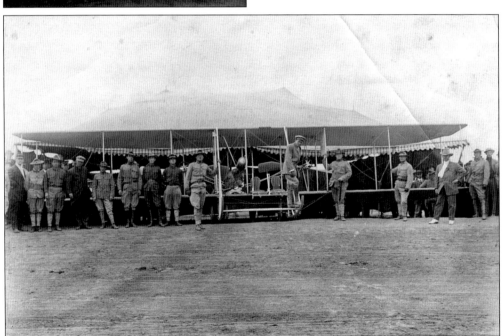

Leonard Bonney's airplane was a Wright Model B named the *Miss Cheyenne* that came complete with an additional seat, allowing him to take passengers. His aircraft is shown here in front of the big top tent with a contingent of Oklahoma National Guard troops. Bonney is standing on the skid of the airplane. (TASM.)

Eugene Lorton, editor of the *Tulsa World* newspaper, drew the short straw when a group of local newsmen vied to be the first passenger to fly in Tulsa. Many say the drawing was fixed in Lorton's favor, seeing as how no one else really wanted to fly. (TASM.)

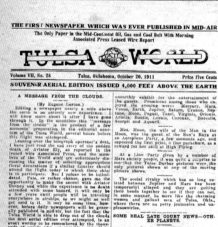

Learning that he won the drawing to be the first passenger to fly in Tulsa, Lorton decided to publish a special miniature edition of the *Tulsa World* for the occasion. He printed 4,400 copies of the edition, throwing out 400 copies as he flew over the crowded fairgrounds. The remaining copies were distributed in a more conventional manner. (Carl Gregory.)

Liberty Airship to Put Muskogee on the Map

Prosperity, with a capital "P." big payrolls, high wages, armies of Muskogee workmen, the hum and throb of machinery, the Oklahoma skies darkened with smoke from great Muskogee factories—these are visions which a number of business men of this city are having since "the Liberty Airship came to town." You may think this is a dream, but go over to the old Court House Bldg., and see and be convinced. The President and Inventor of the new type of aircraft is there giving free demonstrations from 6 to 9 p. m., and he can convince anyone of ordinary intelligence that the Liberty Airship is the only real flying machine ever designed.

We told you before that it traveled straight up at the rate of a mile a minute, that it could stand stock still in the air at any altitude, but it could life five tons, that a fleet of such machines was capable of destroying the German navy, the submarine bases, and Berlin itself in a single night. Whether you doubt these statements or not, you should lose no time in looking the machine over. It won't cost anything, and you will have one big surprise. You will feel like tearing your hair because our "Boys" haven't a few thousand of the machines with them in France. With your co-operation we can soon get them over there, and in the meantime, we can make Muskogee the manufacturing center of the Southwest.

COME IN AND LOOK IT OVER

D. H. FELTON, President
W. H. STELVE, Vice-President
H. K. HERBST, Secretary
JOHN M. COE, Treasurer

The LIBERTY AIRSHIP COMPANY

Phone 376
Muskogee, Okla.

NOTE: No demonstrations will be given May 25 or 26

The early days of aviation produced many short-lived aircraft companies. Many of those early entrepreneurs were earnest in their endeavors. This advertisement for the Liberty Airship Company of Muskogee makes claims that are stronger than their design. None of these contraptions were ever built, but it is a sure bet that some Oklahomans lost a few dollars during the company's capitalization phase. (Carl Gregory.)

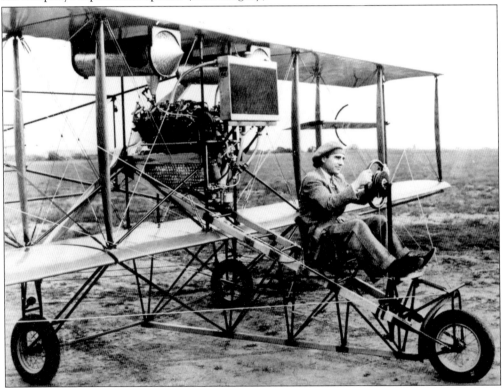

W. D. (Billy) Parker began building aircraft of his own design at the age of 14. During his early building days, he lived in Colorado, but he moved as a young man to Bartlesville to work for Phillips Petroleum, managing its aviation department. His aircraft were definitely inspired by Glenn Curtiss's designs, but he insisted that they were of his own creation. This aircraft hangs today in the Will Rogers World Airport terminal in Oklahoma City. Another one of Parker's pushers, powered by a Gnome-Rhone rotary engine, hangs in the Tulsa International Airport terminal. (TASM.)

Oilman Harold Breene operated an early airport at the corner of Admiral Boulevard and Hudson Street. He used his war surplus JN-4 Jenny in his oil business; in the off times, he sold rides over Tulsa for $25. His pilot, shown here, was J. V. C. Gregory. Notice the swastika painted on the fuselage. While the Nazis perverted the insignia for their own purposes, it was traditionally a Native American symbol of good luck. (TASM, courtesy Bill Crawford.)

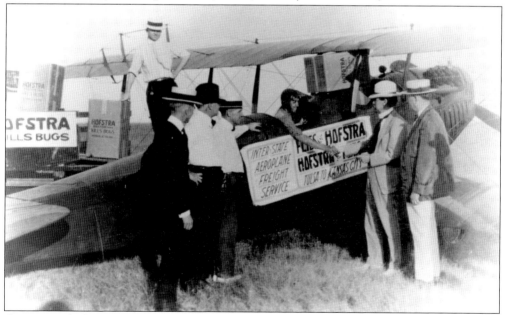

Gregory made the first purported interstate shipment of goods in 1919. He flew a load of Hofstra insect killer from Tulsa to the Ridenour-Baker Grocery Company in Kansas City. Tulsa's Mayor C. H. Hubbard quipped, "It is only a peek into the future of air travel and it is mighty fine that Tulsa was the first to do the peeking." A telegram was received in Tulsa upon Gregory's arrival, stating, "All Kansas City marvels at unbeatable Tulsa." (TASM, courtesy Beryl D. Ford.)

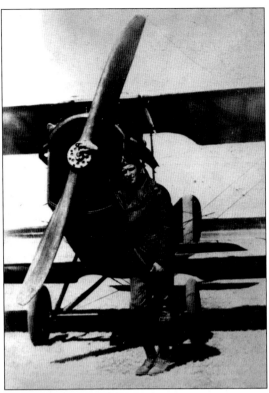

Walter Helmerich was an early barnstormer throughout Oklahoma. His flying career and life nearly ended when he had a collision with a church steeple in Oklahoma City. He discovered a more lucrative and safer lifestyle when he founded Helmerich and Payne Petroleum, one of the few oil companies with headquarters still located in Tulsa. (TASM, courtesy the Helmerich family.)

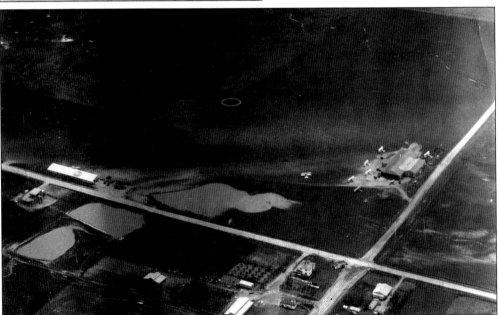

Duncan McIntyre created Tulsa's first truly commercial airport, earning him the moniker "father of Tulsa aviation." His airport was located on the southeast corner of Admiral Boulevard and Sheridan Road. McIntyre's airport was considered to be one of the finest natural airfields in the country. It boasted hangar space for 24 aircraft and a beacon for night landings that could be seen for 50 miles. (TASM, courtesy Margaret McIntyre.)

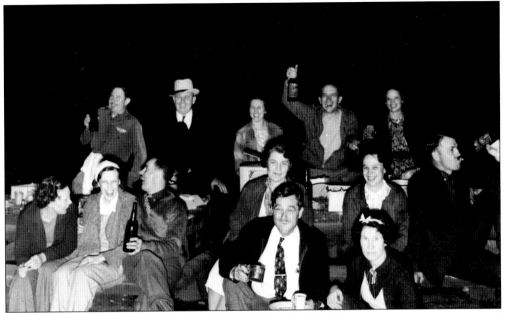

Tradition holds that when a student pilot finally becomes a solo pilot, the instructor cuts off the pilot's shirt (providing the pilot is male) and throws a party. Prohibition did not deter the festivities. Taking the precaution of partying at night so as not to draw the attention of local law enforcement, the solo parties were a regular event at McIntyre Airport. McIntyre is in the front row, third from the left. (TASM, courtesy Margaret McIntyre.)

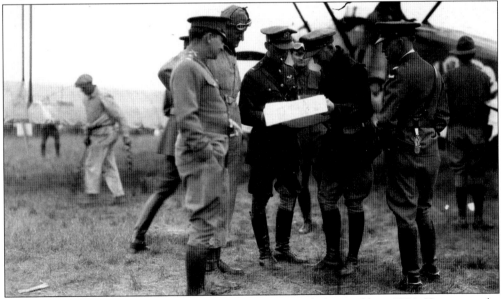

Douglas Aircraft Company flew four of its planes around the world in 1924. Known as the Douglas World Cruisers, the aircraft were named for four cities in the United States: Seattle, Chicago, New Orleans, and Boston. It took them 175 days to circumnavigate the globe; the only Oklahoma stop on their flight took place at Muskogee's Hatbox Field. They arrived on September 18, 1924. This photograph shows some of the pilots and local army personnel going over their charts for the next leg of their trip. (TASM, courtesy Beryl D. Ford.)

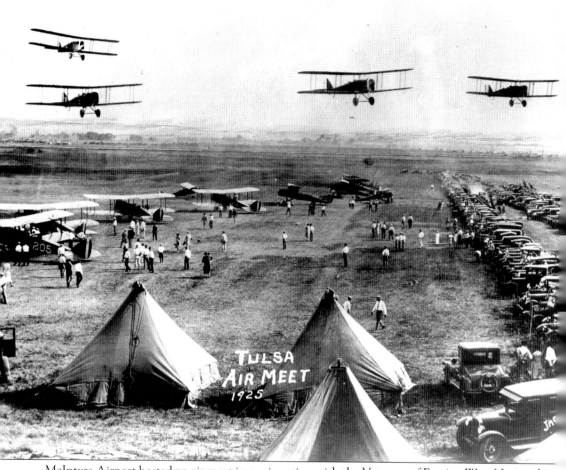

McIntyre Airport hosted an air meet in conjunction with the Veterans of Foreign Wars National Encampment in 1925. Over 75 civil and military aircraft took part in the event. The roster of attendees was akin to a who's who of aviation of the day, with names like Walter Beech, Clyde Cessna, and Lloyd Stearman. The meet featured air races, flight demonstrations, aerobatics, and mass flyovers. Many Tulsans were getting their first taste of aviation, and the crowds were thrilled by the exhibition. It was estimated that nearly 25,000 people attended on the first day alone. This photograph shows many of the military aircraft that were evident at the meet, most of which are DH-4s. While the DH-4 was originally a British airplane, it was also built in the United States with an American Liberty engine. In the foreground are some of the tents pitched by the attendees. (TASM, courtesy Beryl D. Ford.)

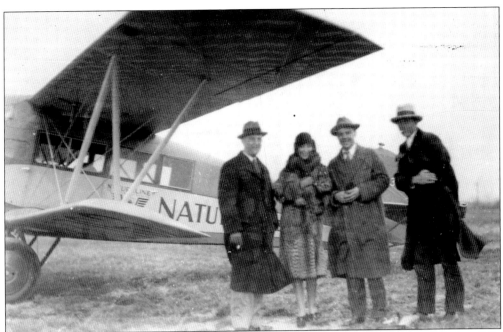

In 1925, Henry Ford and his son Edsel helped create the Ford Reliability Tour. From 1925 to 1931, the tours flew throughout the Midwest to show average Americans that air travel was safe and could be scheduled like trains, especially in the Ford Trimotor. Duncan McIntyre contacted the Ford people to inquire about getting the tour to come to Tulsa. The deal was struck, and on July 9, 1927, the tour arrived at McIntyre Airport. Fourteen aircraft landed from the tour, and locals flew their aircraft in to join the festivities. The participants included the likes of Eddie Stinson, Frank Hawks, and Paul Braniff. The photograph above shows a Buhl Airsedan sponsored by Naturaline, while the second shows a Ford Trimotor. (TASM, courtesy Margaret McIntyre.)

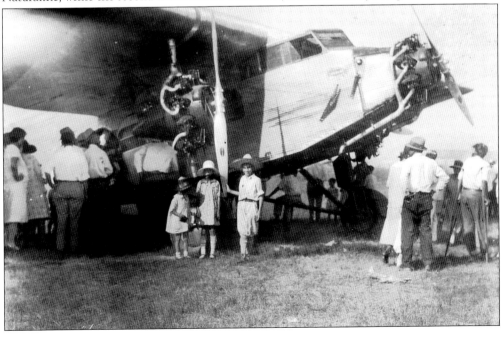

Tulsa was not originally on Charles Lindbergh's goodwill tour in 1927, but local Tulsa businessmen convinced him to stop here by informing his front men of the fact that the Tulsa State Fair and International Petroleum Exposition would be going on, guaranteeing a record crowd. He was to land on September 30, 1927, and to ensure that he could easily find McIntyre Airport, a giant arrow was painted on top of Reservoir Hill north of downtown Tulsa that pointed toward the airport. (TASM.)

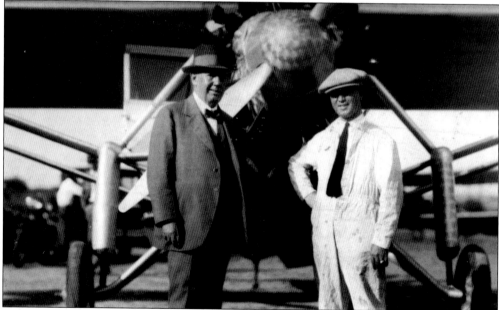

Lindbergh told the Tulsa chamber that it must keep the landing field cleared of all people, or he would simply bypass Tulsa and fly on to Muskogee. To ensure security, McIntyre's mechanic Nile Menkemiller (right) was in charge of keeping people off the field. He was also in charge of marshaling the *Spirit of St. Louis* into a protective enclosure once it landed to keep it safe from souvenir hunters. This photograph does prove that he let at least one gentleman in to get his picture taken with it. (TASM, courtesy Margaret McIntyre.)

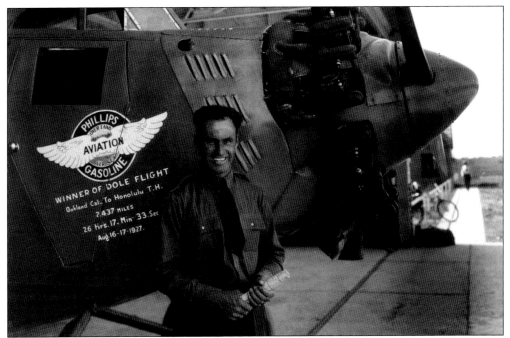

In Bartlesville, Frank Phillips, founder of Phillips Petroleum, was busy supporting aviation. Phillips sponsored pilot Art Goebel (above) in the Dole Race from Oakland, California, to Oahu, Hawaii. Another Dole racer, Bennett Griffin, flew the *Oklahoma*, also sponsored by Phillips. Goebel won the race with his Travel Air 5000 named *Woolaroc*, which was the name of Phillips's ranch, meaning woods, lakes, and rocks. Today the airplane hangs in the museum of the same name near Bartlesville. Phillips Petroleum aviation department chief Billy Parker and Phillips started the Star Aircraft Company and manufactured the Cavalier (below). The company built 55 before ceasing production. (TASM, courtesy Dale Frakes.)

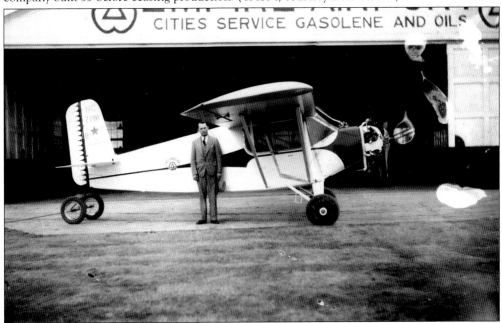

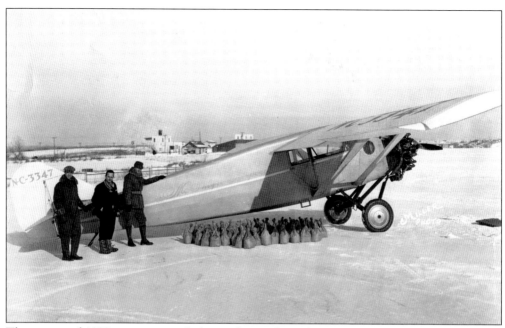

The winter of 1930 was a particularly tough one for Tulsa. Snow began early in the season and continued to pile up until the city was at a standstill. Tulsa's lowest recorded temperature of 16 degrees below zero was recorded during that winter. Tulsa's largest public park, Mohawk Park, was experiencing an unprecedented mortality rate among the bird population due to the bitter cold and lack of food. Duncan McIntyre devised a humanitarian relief effort of this own. He loaded his Stinson Detroiter with bags of birdseed, flew over Mohawk Park, and dropped the seed to the starving birds on the ground. The photographs show McIntyre (above, center) with his mechanic Nile Menkemiller (right) and an unidentified man at McIntyre Airport as they prepare to load McIntyre's Stinson Detroiter for the mercy flight. (TASM, courtesy Margaret McIntyre.)

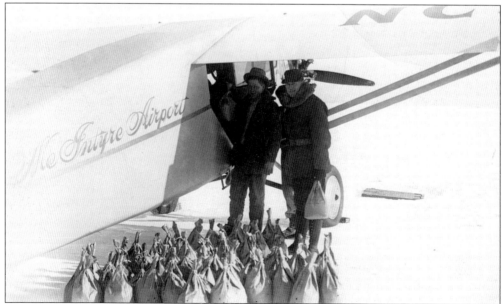

Two

A DREAM IS REALIZED

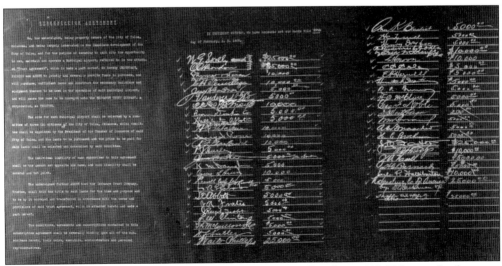

With the exit of the Ford Reliability Tour and Charles Lindbergh in 1927, Tulsa city leaders were left with one admonition: build a larger city-owned airport. They formed a committee to search for a location and eventually settled on a 490-acre wheat field at the northeast corner of Apache Street and Sheridan Road. They were able to get the airport completed in time for the 1928 Ford Reliability Tour's arrival on July 3, 1928. (TASM, courtesy Tulsa Airport Authority.)

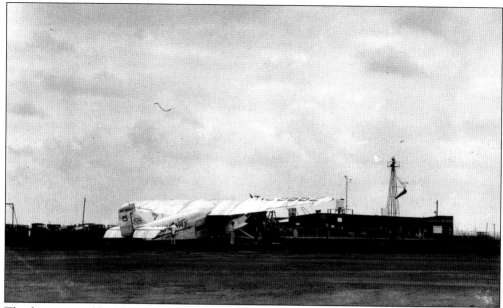

The first terminal building was nothing more than a wood and tar paper shack, but it contained everything that was needed, including a manager's office, post office, weather station, café, and waiting room. This terminal served the airport until 1932 when the new art deco terminal was completed. The aircraft is a S.A.F.E.Way Ford Trimotor, 5-AT-29. (TASM, courtesy Tulsa Airport Authority.)

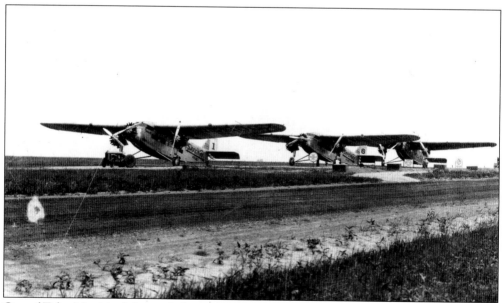

One of Tulsa Municipal Airport's first airlines was S.A.F.E.Way Airlines, or Southwest Air Fast Express. The founder of the company was Duncan oilman Erle P. Halliburton. Operating Ford Trimotors and Lockheed Vegas, S.A.F.E.Way began operations in 1929 with service between St. Louis and Dallas and points in between. The company lasted little more than a year when it was bought up in a complicated sales scheme that became American Airlines. Pictured are 5-AT-13 and 5-AT-39. (TASM, courtesy Tulsa Airport Authority.)

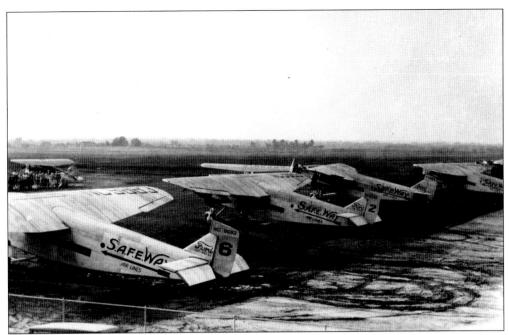

This photograph shows the lineup of S.A.F.E.Way Ford Trimotors near the terminal building fence. This must be a later photograph than the previous due to the fact that the ramps are now paved with concrete. One of the Lockheed Vegas can be seen in the background. (TASM, courtesy Tulsa Airport Authority.)

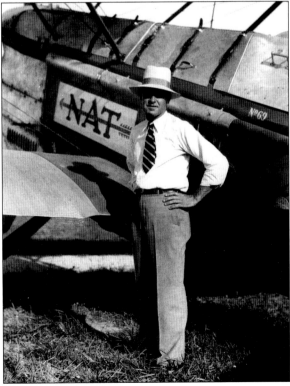

Tulsa Municipal Airport manager Charles W. (Charlie) Short ruled the airport with an iron fist. He was so tough that many referred to the airport as "Short Field." Be that as it may, he was known and loved by many in aviation during his 27-year tenure. Here Short stands beside a National Air Transport Douglas M-2 mail plane. He is wearing his signature white fedora that is evident in most of the photographs of the early airport. (TASM, courtesy Tulsa Airport Authority.)

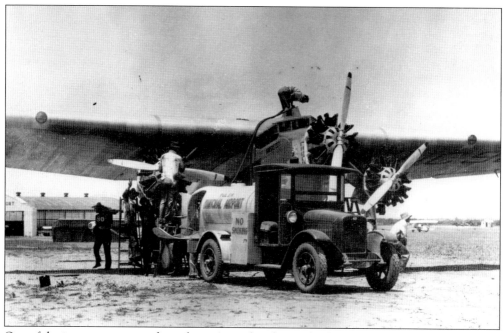

One of the improvements made to the airport after the Ford Reliability Tour left was to purchase state-of-the-art fuel trucks. Here one fuels up a S.A.F.E.Way Ford Trimotor. Other improvements included paved aprons and ramps, oiled gravel runways, and a beacon for night operations. Hangar 1 is in the left background. (TASM, courtesy Tulsa Airport Authority.)

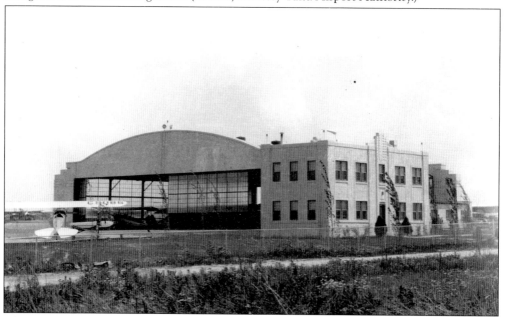

This is Hangar 1, which housed the aircraft of many of the aviation greats from the golden age of aviation, including Charles and Anne Morrow Lindbergh, Amelia Earhart, Wiley Post, Jimmy Doolittle, Frank Hawks, and others. Also seen in this photograph is the art deco pilots' hotel known as Ye Slippe Inn, which was built in 1928. It also served as the home of Charlie and Sybil Short. (TASM, courtesy Tulsa Airport Authority.)

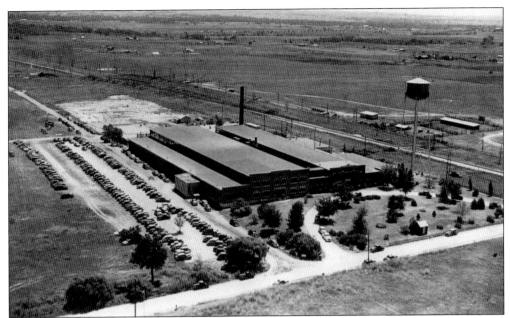

W. G. Skelly built his new Spartan Aircraft Company in 1928 less than a mile south of the new airport at Sheridan Road and Virgin Street. Within the year, he also started Spartan School of Aeronautics. This photograph shows just how rural the location of the factory and the airport was. The location of the airport was advertised as being "5 miles east of the city." (TASM, courtesy Tulsa Airport Authority.)

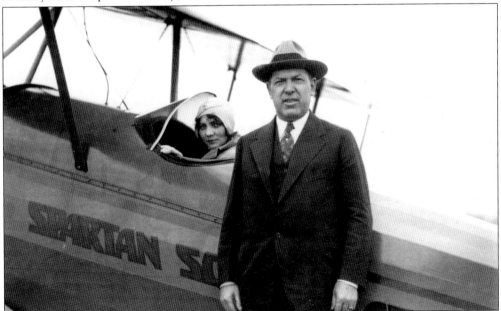

Skelly stands beside one of his new Spartan C-3s marked in the livery of Spartan School of Aeronautics. In the cockpit is Mae Haizlip, who for a short while was a test pilot for the Spartan Aircraft Company. Haizlip learned to fly at the University of Oklahoma and was instructed by the man that became her husband, James Haizlip. She later set a new women's speed record that stood for six years. (TASM, courtesy Tulsa Airport Authority.)

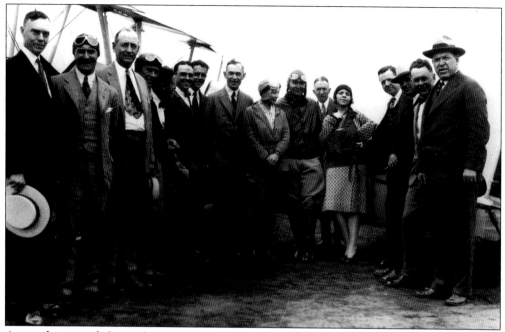

A crowd surrounds James (seventh from the right) and Mae Haizlip (eighth from the right) at Tulsa Municipal Airport. W. G. Skelly (far right) and Charlie Short (third from the right) are in the lineup as well. For the short time that the Haizlips were in Tulsa, James flew for S.A.F.E.Way Airlines. (TASM, courtesy Tulsa Airport Authority.)

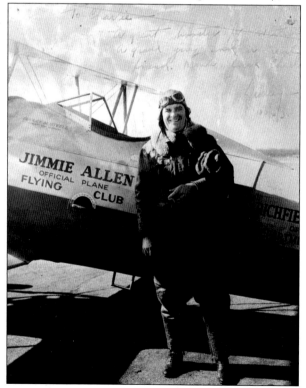

As a promotion, Skelly Oil Company sponsored *The Air Adventures of Jimmie Allen*. The radio program ran from 1933 to 1947 and was broadcast in Tulsa on KVOO radio. Skelly painted one of his Spartan aircraft to promote the *Air Adventures of Jimmie Allen* and hired pilot Dudley M. Steele to fly it to air shows and fly-ins. (TASM, courtesy Tulsa Airport Authority.)

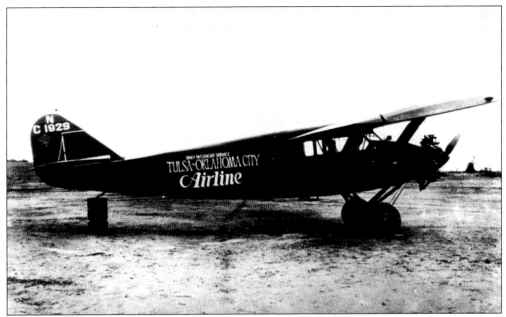

One of Tulsa's early airlines was Tulsa-Oklahoma City Airline. In the beginning, the airline had only three employees, owner Tom Braniff, pilot Paul Braniff, and E. E. Westervelt. The photograph above shows their Stinson SM-1 Detroiter that they began with; soon they added Lockheed Vegas (below). Notice in the photograph below that the name has changed to Oklahoma Airlines. The name was soon changed again to Braniff Airways. Through the decades, the airline grew, adding routes in Mexico and Central and South America. Eventually it became Braniff International, with routes around the world. Braniff International was the only American airline that had plans to fly the Concorde. However, before this took place, the airline went bankrupt. (TASM.)

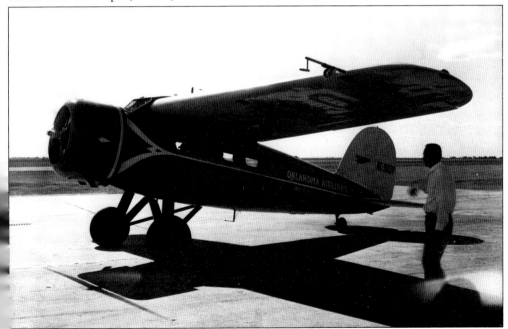

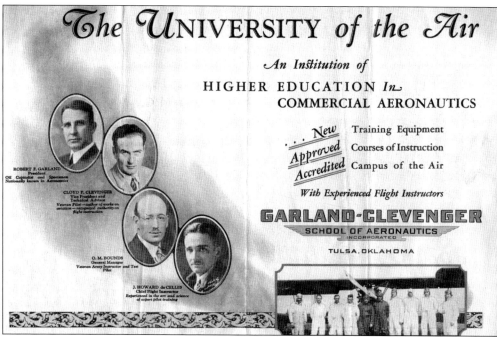

Another Tulsa oilman got into the aviation flight school business in 1929. Robert Garland and Cloyd Clevenger started the Garland-Clevenger School of Aeronautics. Their school was located on the northwest corner of Fifty-first Street and Sheridan Road. The image above is the inside of the brochure that they often dropped from aircraft over events where crowds gathered. The photograph below shows one of their training aircraft on their airfield on March 15, 1929. From left to right are Sherman Willard, Fred Lord, Captain Ferill (chief of Mexico Civil Air Service), Garland, Robert Fierro (chief of military aviation, Mexico), Dr. DeCellos, Parker Cramer, Clevenger, and Al Williams. (Above, Elmo Maurer; below, TASM, courtesy Tulsa Airport Authority.)

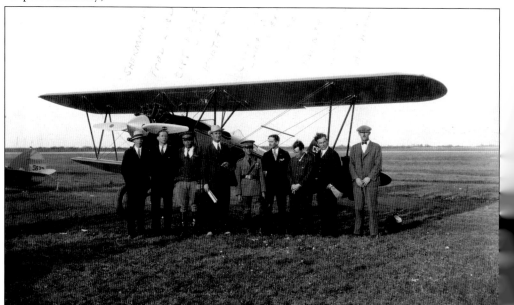

By 1930, Tulsa Municipal Airport was purported to be the busiest airport in the world. This letter shows how the Tulsa Chamber of Commerce was capitalizing on the traffic through the airport. The figures may be suspect, but regardless of the method used to tally the passengers, the airport was very busy due to the oil boom that was ongoing in and around Tulsa. (TASM.)

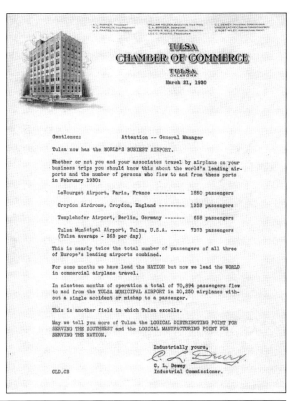

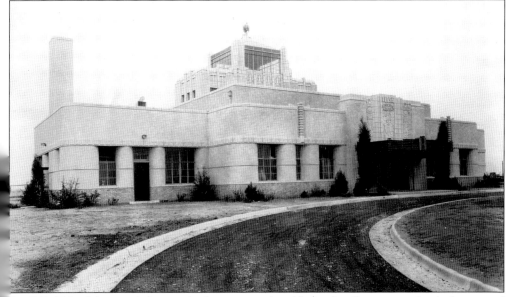

By 1931, Tulsa Municipal Airport had outgrown the old wood and tar paper shack that served as its terminal since 1928. Architect Leon Senter designed the new terminal in the art deco style that had already been incorporated into the pilots' hotel next to Hangar 1. The dedication was set for March 24, 1932, with an all-day celebration. Attendees included Wiley Post, Frank Hawks, Jimmy Doolittle, and Art Goebel. The photograph shows the terminal upon completion. (TASM, courtesy Bob Buckingham.)

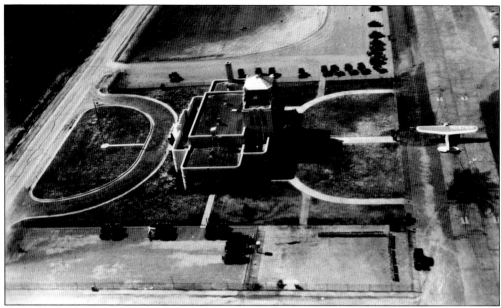

This aerial view of the new art deco terminal (above) shows its location in relation to the airport. Situated on the north side of Apache Street about a quarter mile east of Sheridan Road, the new terminal featured a circular drive, an integral control tower, and a ramp that allowed four airplanes to load simultaneously. Constructed of stucco and terra-cotta, the entrance was guarded by a giant angel that watched over the arriving passengers. The external decorations were terra-cotta and had floral and aviation motifs, including engine cylinders and propellers. Inside there was a large waiting room for passengers, airline ticket counters, a restaurant, a weather station, a post office, and a manager's office. The photograph below was taken sometime in the 1950s, but it shows the attention to detail that was found throughout the interior of the terminal. (Above, TASM, courtesy Bob Buckingham; below, TASM, courtesy Tulsa Airport Authority.)

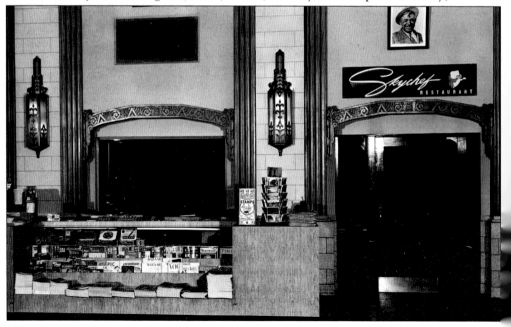

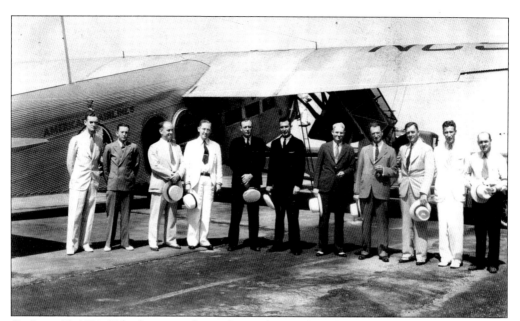

On June 15, 1934, Tulsa began a relationship with an airline that continues today. A lone Ford Trimotor arrived at 2:30 p.m. and rolled up to the former S.A.F.E.Way hangar on the east end of the airport. The company, American Airlines, had leased the hangar to service its aircraft. City dignitaries met the airplane to celebrate its arrival. Charlie Short is on the right. (TASM, courtesy Tulsa Airport Authority.)

This is the American Airlines ticket counter in the Tulsa Municipal Airport terminal. It was decided shortly after the terminal was built that it was too small, and this photograph shows just how little room there was. Notice the neon American Airlines sign suspended over the counter. The stairs to the right lead to Short's office. (TASM, courtesy Tulsa Airport Authority.)

33

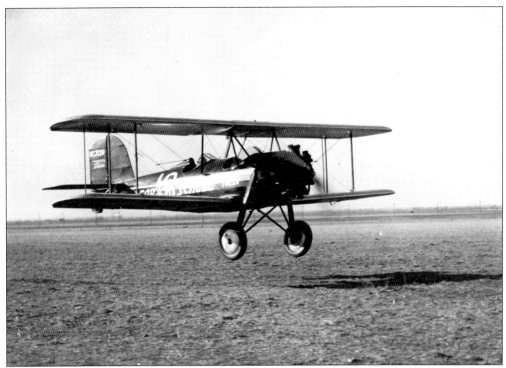

This beautiful shot of a Spartan C-3 landing at Tulsa Municipal Airport shows why W. G. Skelly was so impressed with the airplane. Because of the Depression, the sales of the C-3 were not what they could have been, so few were made. Skelly looked for a cheaper alternative and found it in the Spartan C-2. (TASM, courtesy Spartan College of Aeronautics and Technology.)

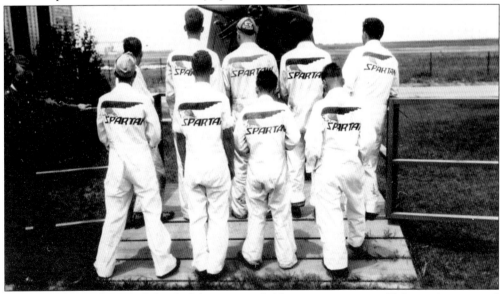

Being a student at Spartan School of Aeronautics held a certain mystique. To be working toward a career in this new world of aviation was a source of pride. The white Spartan coveralls became a badge of honor with the embroidered logo on the back. These early students show off their coveralls for the camera. (TASM, courtesy Jess Green.)

Three

PLANES, PERSONALITIES, AND PROMOTION

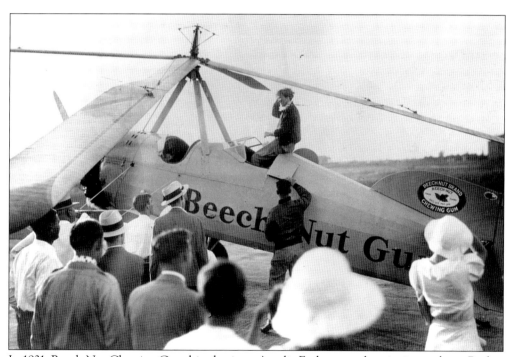

In 1931, Beech-Nut Chewing Gum hired aviator Amelia Earhart to advertise its products. Rather than a traditional airplane like her Lockheed Vega, Earhart flew the Pitcairn PCA-2 Autogiro. Arriving in Tulsa on June 17, 1931, Earhart was greeted by an enthusiastic crowd of admirers. She intended to stay only one night in Tulsa, but during her flying demonstration, she encountered a problem and the craft was rolled into Hangar 1 for repairs. (TASM, courtesy Beryl D. Ford.)

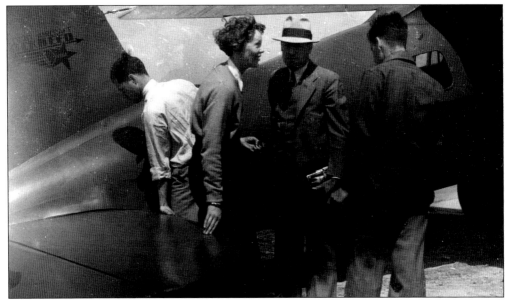

Amelia Earhart made several stops in Tulsa during her short life, including her participation in the 1929 Powder Puff Derby and her Beech-Nut Chewing Gum tour. This photograph shows Earhart at Tulsa Municipal Airport in her famous red Lockheed Vega that she flew across the Atlantic Ocean. Not a scheduled stop, she had control problems and decided to land in Tulsa. From left to right are Bill Coleman, Charlie Short, J. Q. Meyers. (TASM, courtesy Tulsa Airport Authority.)

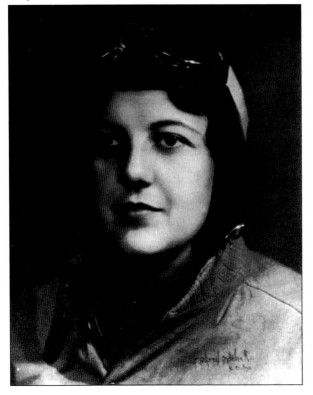

Tulsan Dorothy McBirney, a pilot in her own right, was a good friend of Earhart's. Earhart often visited the McBirneys when she was in town. McBirney became the governor of the south-central section of the Ninety-Nines from 1934 through 1936. Earhart was the first president of the Ninety-Nines, an organization that she helped found. (TASM, courtesy Tulsa Airport Authority.)

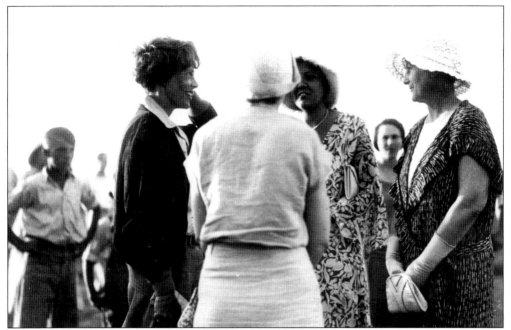

McBirney (center, facing camera) visits with Earhart (left, center) during her Beech-Nut Chewing Gum tour visit in 1931. In the background are many avid fans of Earhart who are probably very jealous of McBirney for taking personal time with Earhart. The young boy behind Earhart seems downright indignant. (TASM, courtesy Tulsa Airport Authority.)

Charles and Anne Morrow Lindbergh were frequent visitors as well. Charles's first visit was his 1927 landing at McIntyre Airport during his goodwill tour. Here they pose for a snapshot in Short's office inside the terminal building. Notice the rogue's gallery on the walls of his office. (TASM, courtesy Tulsa Airport Authority.)

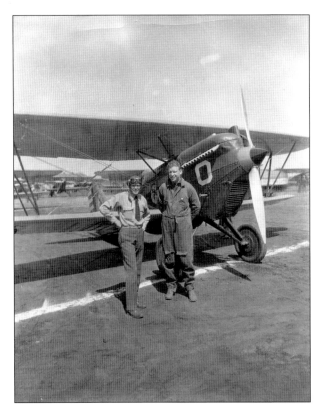

On May 14, 1931, an army air tour stopped in Tulsa. Over 50 Curtiss Hawk biplanes landed at Tulsa Municipal Airport. During the army's tour through the country, there were outcries of governmental waste in the height of the Great Depression. Those that loved airplanes simply enjoyed the sound of the engines and the aerial flight demonstrations. Here two army pilots pose in front of one of the Curtiss Hawks for Charlie Short's camera. (TASM, courtesy Tulsa Airport Authority.)

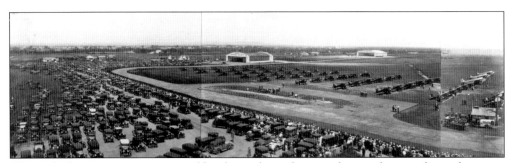

This early-day panorama was created by gluing three photographs together to take in the entire scene at Tulsa Municipal Airport. It is a wonderful photograph of the 1931 visit of the army tour. Evident is the great interest in aviation, with the throng of automobiles lined up just inside the airport fence. This view shows not only the Curtiss Hawk biplanes but also three army Ford Trimotors (right). (TASM, courtesy Tulsa Airport Authority.)

Earl Rockwood was a pilot for National Air Transport, and he had the honor of flying the first airmail out of the city of Tulsa. He came in for the Ford Reliability Tour festivities at the opening of Tulsa Municipal Airport on July 3, 1928. He flew out on the fifth with the mail. (TASM, courtesy Tulsa Airport Authority.)

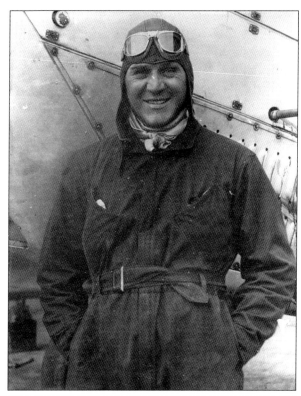

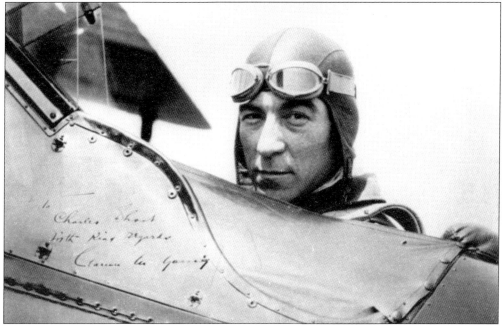

Clarence M. Young was a World War I aviator. When he returned to the states after the war, he became a barnstormer throughout the Midwest. He crossed paths with Charles Lindbergh, and they became fast friends. Young became the assistant secretary of commerce for aeronautics from 1929 to 1933 and was a frequent visitor to Tulsa. (TASM, courtesy Tulsa Airport Authority.)

During the 1920s, Frank Phillips hosted the annual Cow Thieves and Outlaws reunion at his Woolaroc ranch outside Bartlesville. The guests included not only the rich and famous but also the notorious. A truce was called between lawmen and outlaws from sunup on the day of the event until sunup of the day after, and all guns had to be left at the gate. Some of the guests seen at the annual gathering included the likes of Will Rogers, I. E. du Pont, Harry Truman, and Herbert Hoover. Pilots were favorite invitees as well. Wiley Post (left) is shown here dressed in the appropriate if not outlandish garb, as many guests did. Below, Art Goebel (left) and Charlie Short (right) enjoy the festivities inside the Woolaroc lodge. (TASM, courtesy Tulsa Airport Authority.)

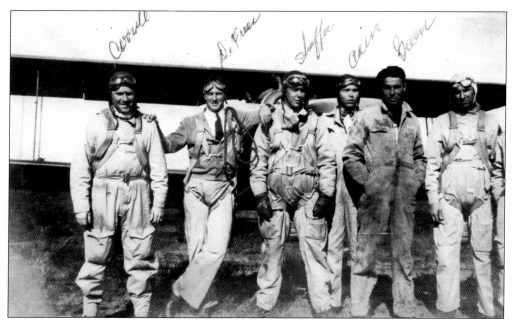

This is a lineup of Spartan School of Aeronautics pilots, part of a group known as the Dawn Patrol. Capitalizing on the mystique and chivalry of World War I flyers, the Dawn Patrol was created as a promotional tool for Spartan. Second from the right is Jess Green, who became the director of the school in 1936. The pilots often took part in statewide air tours to tout Spartan. (TASM, courtesy Jess Green.)

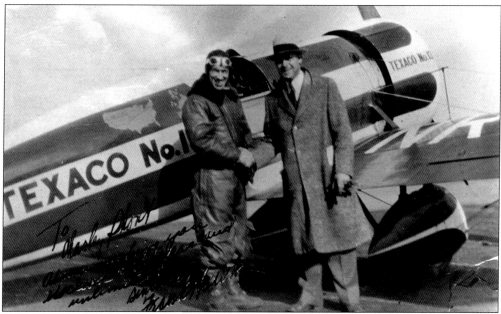

Air racer Frank Hawks was a frequent visitor to Tulsa Municipal Airport. Here he is with Short (right) and the Texaco No. 13 Travel Air Mystery Ship. Hawks crashed in this airplane in 1932, nearly losing his life in the accident. He recovered, and in 1933, he set the transcontinental airspeed record when he flew from Los Angeles to Brooklyn in 13 hours, 26 minutes, and 15 seconds. (TASM, courtesy Tulsa Airport Authority.)

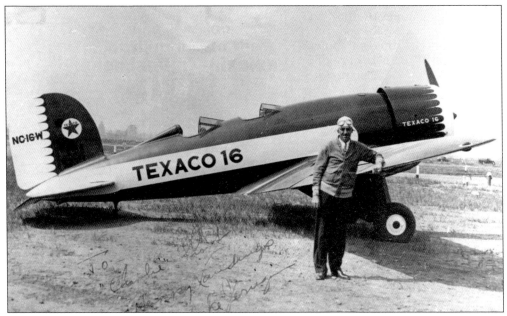

Duke Jernigan and Frank Hawks devised a plan to tow a glider across the country from San Diego to New York in 1930. The glider, known as the *Texaco Eaglet*, was piloted by Hawks, and Jernigan flew the Texaco No. 7 Waco biplane as the towplane. The trip was successful and took 44 hours and 10 minutes of actual flight time. Jernigan is seen here with the Texaco No. 16. (TASM, courtesy Tulsa Airport Authority.)

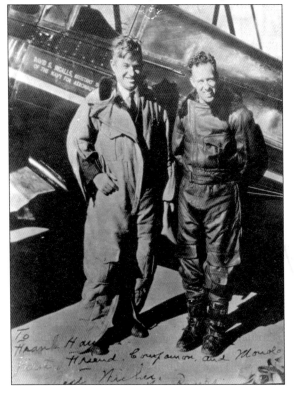

Hawks (right) gave Amelia Earhart her first airplane flight in 1920. This passenger, Will Rogers (left), although a huge proponent of aviation, was content to remain a passenger rather than learning to fly. When Hawks was injured in the crash of the Texaco No. 13, Rogers wrote him a note that asked, "What's the matter with you anyhow, are you getting brittle?" (TASM, courtesy Tulsa Airport Authority.)

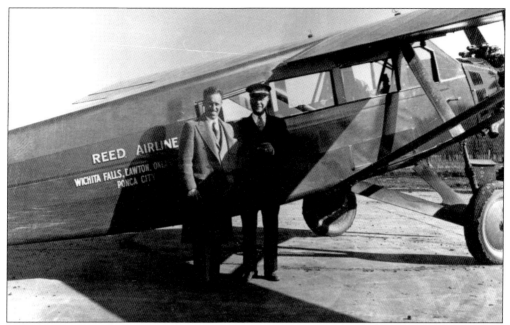

Joe Reed (right) opened a flying school in Lawton and eventually started Reed Airlines, flying throughout Oklahoma and Texas. He is shown here with Hawks and his Travel Air 6000. The aircraft was christened the *Romancer* because Charles Lindbergh borrowed it to fly to Mexico City in 1929 to visit his future wife, Anne Morrow Lindbergh. (TASM, Tulsa Airport Authority.)

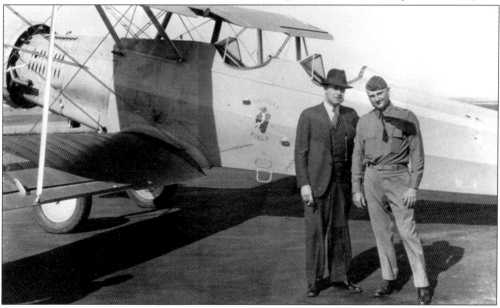

Tulsan I. A. "Woody" Woodring (right) was one of the Three Musketeers of the Air, an army flying team that was formed at Selfridge Field in Michigan. He replaced Thad Johnson when Johnson was killed flying in Canada. When another musketeer was killed in an accident at an air race in 1928, Charles Lindbergh immediately took his place, and the races continued. Charlie Short (left) poses with Woodring at Tulsa Municipal Airport. (TASM, courtesy Tulsa Airport Authority.)

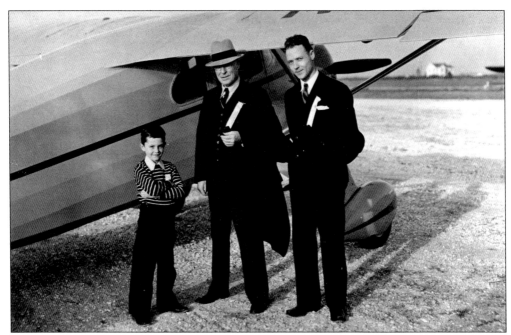

George E. Haddaway (right), editor of *Southern Flight* and later *Flight* magazines, was a frequent visitor to Tulsa. He is shown here with Jim Brazzel (center) and an unidentified boy. Haddaway published a multipage article about Tulsa Municipal Airport in a 1930 issue of his *Southern Flight* magazine, bringing national attention to Tulsa. (TASM, courtesy Tulsa Airport Authority.)

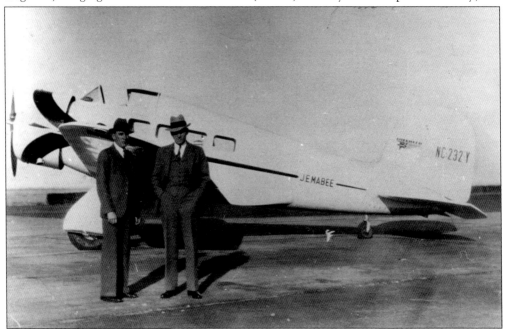

Tulsa oilman John E. Mabee (right), known as Oklahoma's "Mr. Philanthropy," used aircraft in his oil business. Once he garnered his oil fortune, he took on another career of giving away his fortune for worthy causes. This aircraft is a Lockheed Orion, seen here at Tulsa Municipal Airport with an unidentified gentleman. (TASM, Tulsa Airport Authority.)

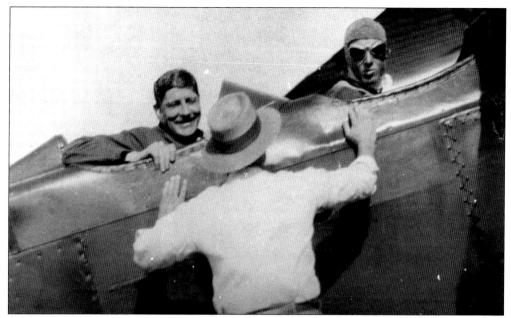

Patrick J. Hurley (rear cockpit), born in the Choctaw Nation, Indian Territory, in 1883 became secretary of war in 1929 under Pres. Herbert Hoover. He later served as the U.S. ambassador to China from 1944 to 1945. He is seen here preparing to take off from Tulsa Municipal Airport as Charlie Short yells his goodbye over the roar of the engine. (TASM, courtesy Tulsa Airport Authority.)

Actress Ruth Chatterton made the transition from silent films to talkies, starring in such movies as *Madame X* and *Sarah and Son*, both of which earned her Academy Awards. She was an early-day aviator and was good friends with Amelia Earhart. While this is no doubt a publicity photograph, it includes a personal message to Short, which is barely visible. (TASM, courtesy Tulsa Airport Authority.)

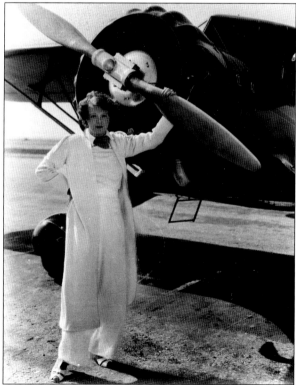

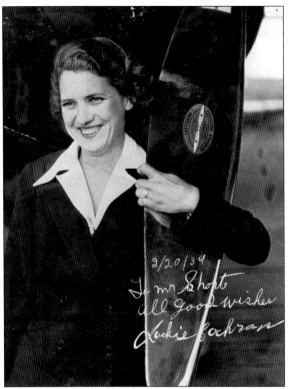

Jacqueline Cochran flew her first race in 1937, and from that point on, she set record after record. By the end of the 1930s, she was considered by many to be the best woman pilot in the country. She is perhaps best known for having helped form the Women's Auxiliary Army Corps (WAAC) and the Women's Air Service Pilots (WASPs) during World War II. (TASM, courtesy Tulsa Airport Authority.)

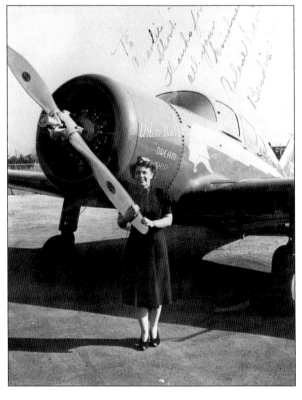

Arlene Davis earned her pilot's license in 1931. She flew her bright red Spartan Model 7-W Executive in the 1939 Bendix Air Race, finishing in fifth place. She is shown here with the Spartan, named *Dream Ship*, with the bright yellow Spartan insignia flashing down the side of the aircraft. (TASM, courtesy Tulsa Airport Authority.)

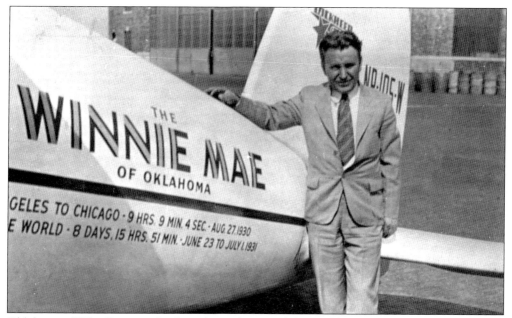

Oklahoman Wiley Post was the first pilot to fly around the world. With his navigator, Australian Harold Gatty, it took them eight days, 15 hours, and 51 minutes to circumnavigate the globe. The aircraft that he flew was his boss F. C. Hall's Lockheed Vega named the *Winnie Mae of Oklahoma*. Winnie Mae was Hall's daughter. Wiley is shown next to the aircraft; the photograph was probably taken in Bartlesville. (TASM, courtesy Conoco Phillips.)

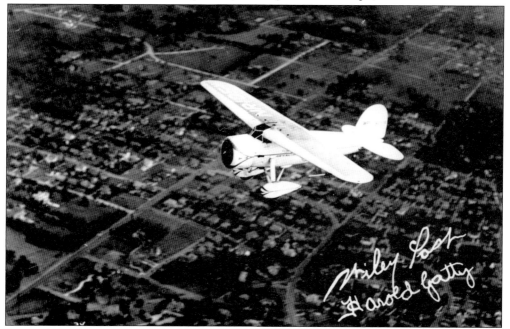

Post and Gatty were invited to Tulsa for a celebration of their flight around the world in 1931. Engineers Aerial Survey of Tulsa arranged to have a plane in the air to photograph their arrival. This is one of its shots of the *Winnie Mae of Oklahoma* as it flew into Tulsa Municipal Airport. (TASM, courtesy Tulsa Airport Authority.)

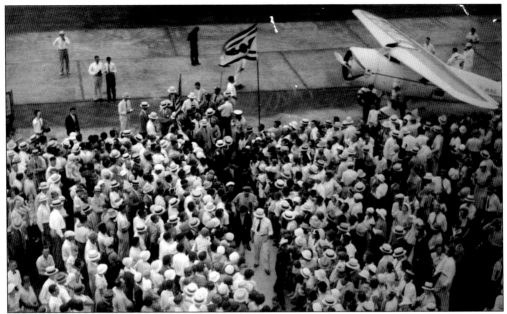

Thousands turned out to greet Wiley Post and Harold Gatty. This view was taken from the top of the Tulsa Municipal Airport terminal. Charlie Short (wearing a white hat by the sailor) is leading the procession with Wiley Post behind (wearing a white eye patch by the sailor and police officers). Gatty does not appear evident in this photograph. (TASM, courtesy Tulsa Airport Authority.)

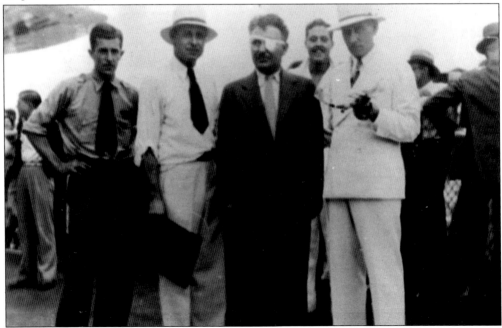

From left to right, this photograph shows Gatty, Short, Post, and an unidentified man as they pose for the camera beside the *Winnie Mae of Oklahoma* (wingtip at left). The around-the-world duo were soon bustled off to a waiting car for the long ride to downtown. (TASM, courtesy Tulsa Airport Authority.)

Post and Gatty were feted with a parade and dinner that evening. Schools were let out and tens of thousands attended the parade. This photograph captures the parade as it moves down Admiral Boulevard. In the automobile is Short in the front passenger seat. Post (left, with his hand raised) and Gatty (right) are in the rear seat. (TASM, courtesy Tulsa Airport Authority.)

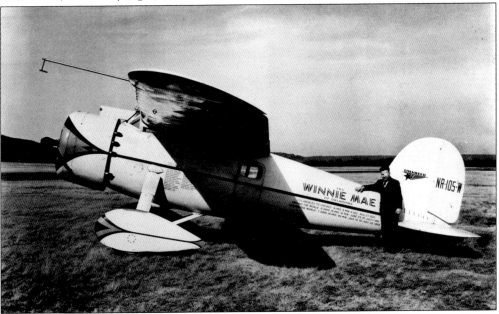

In July 1933, Post flew around the world solo and bested the time that he and Gatty set. Notice that in some photographs Post wears an eye patch and in some he does not. He lost his left eye in an oil patch accident. He had a glass eye made, but he could not wear it when he flew because it got cold and gave him a headache, so he wore his white eye patch. (TASM, courtesy Conoco Phillips.)

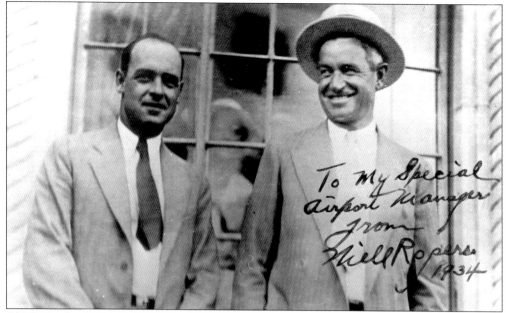

Oklahoma humorist Will Rogers (right) and Charlie Short pose for the camera in this 1934 photograph. Will Rogers was one of the most vocal proponents of aviation. Although never a pilot himself, he flew every chance he got and always weighed in on aviation stories of the day on his syndicated radio program and in his newspaper column. (TASM, courtesy Tulsa Airport Authority.)

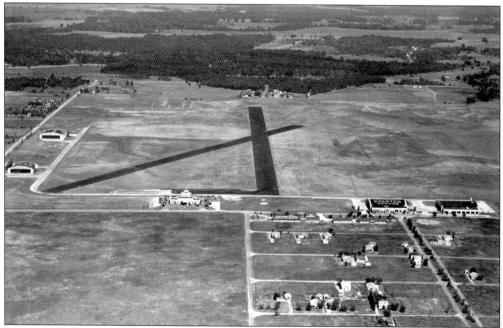

This aerial view of Tulsa Municipal Airport shows Spartan School of Aeronautics on the lower right with the classroom buildings on the south side of Apache Street and the Spartan hangars on the north side of the street. The boulevard that runs north and south from the Spartan service hangar was named Charles Lindbergh Boulevard. (TASM, courtesy Tulsa Airport Authority.)

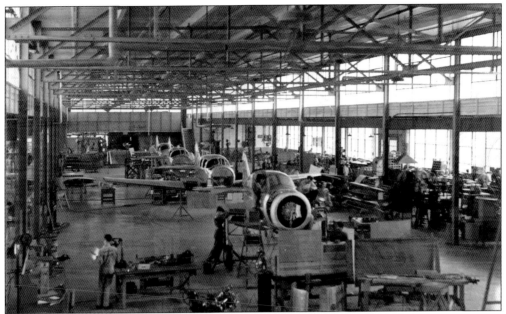

While the Spartan Aircraft Company built several different types of aircraft from its inception in 1928, perhaps the aircraft that it is best known for is the Spartan Model 7-W Executive. It was one of the earliest all-metal corporate aircraft built beginning in 1934. This view shows the Spartan factory with the Model 7-W Executive line. A total of 34 were built. (TASM, courtesy Spartan College of Aeronautics and Technology.)

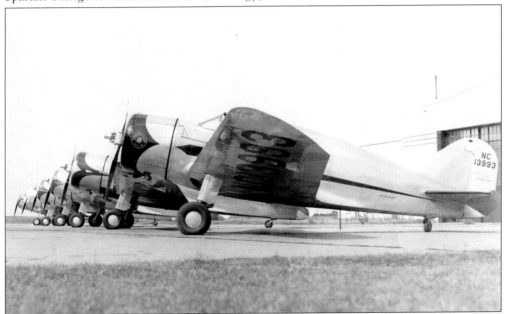

This lineup of Spartan Model 7-W Executives shows the beautiful lines of the aircraft. The photograph was taken on the ramp of the Spartan service hangar. Originally selling for $47,000, today it costs well over a quarter of a million dollars when one does become available. At this writing, there are still approximately 22 left in flying condition. (TASM, courtesy Spartan College of Aeronautics and Technology.)

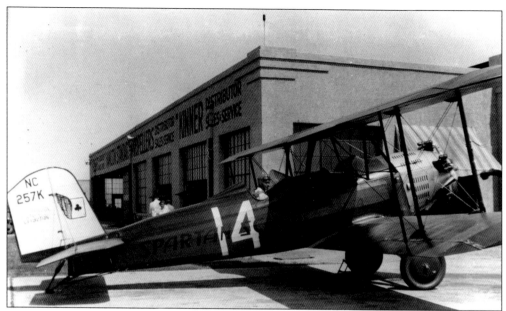

Two other aircraft built by the Spartan Aircraft Company were the C-3-225 (above) and the C-2-165 (below). The C-3-225 was the same basic airframe that was designed by Willis Brown in 1926. W. G. Skelly bought Brown's company, the MidContinent Aircraft Company, and started Spartan Aircraft Company in 1928. The C-2-165 was designed to satisfy a need for a less-expensive aircraft, considering that the Depression was in full swing. On Spartan aircraft, the C stood for *civil* and the number was the number of people it carried, so the C-3 carried one in the rear cockpit and two in the front. The C-2-165 pictured is equipped with a hood in the rear cockpit to teach "blind," or instrument flying. (TASM, courtesy Spartan College of Aeronautics and Technology.)

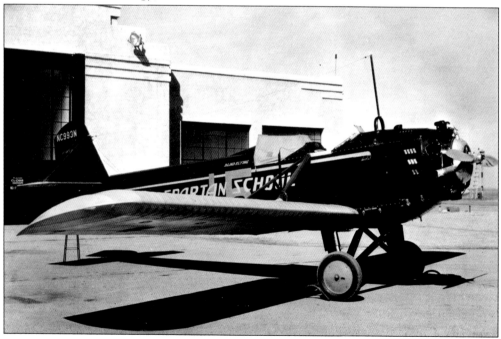

This is an interesting shot of Tulsa Municipal Airport and Spartan School of Aeronautics taken from a Spartan Model 7-W Executive. In the lower portion of the photograph is its very distinctive pointed wingtip. This one has the Chinese national insignia applied to it because Spartan was in talks with the Chinese, hoping to sell several of its aircraft. (TASM, courtesy Spartan College of Aeronautics and Technology.)

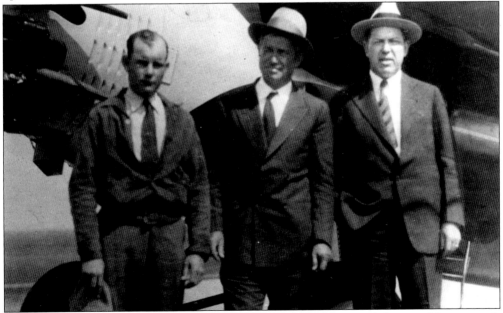

Oklahoman Will Rogers was a frequent flyer through Tulsa Municipal Airport. He even took up for Charlie Short when new Tulsa mayor Herman Newblock tried to replace Short as airport manager. Here Rogers poses for a shot with Skelly (right) and S.A.F.E.Way pilot Bob Cantwell (left). The aircraft is Erle P. Halliburton's Lockheed Vega that Cantwell flew in the 1928 Ford Reliability Tour. (TASM, courtesy Tulsa Airport Authority.)

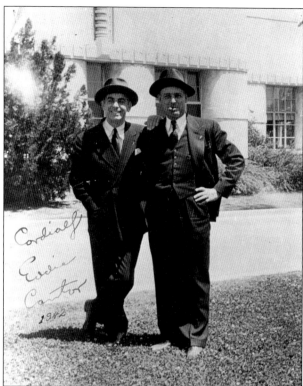

Actor and star of Broadway Eddie Cantor (left) visited Tulsa in 1942. As was his way, Charlie Short had to have his photograph taken with Cantor. Here they are clowning around in front of the Tulsa Municipal Airport terminal. Notice that their hat brims are snapped up in front, which was Cantor's signature look. (TASM, courtesy Tulsa Airport Authority.)

While Short was Mr. Tulsa Municipal Airport, he did have a family. His wife, Sybil Short (left), and their son Billy Short (right) were on the airport nearly as much as he was, considering that their home was in the Ye Slippe Inn, the pilots' hotel on Sheridan Road. Billy served in the Army Air Corps in World War II. (TASM, courtesy Tulsa Airport Authority.)

In 1933, the Boeing Company introduced the 247. This was the first modern, all-metal passenger liner with twin engines and retractable landing gear. While the early models had the old-style cowl rings as shown in these photographs, the later models had National Advisory Committee for Aeronautics (NACA) cowlings that fully enclosed the engines. While the 247 was the first, it was soon outmoded by the Douglas DC-3. The photograph above shows an NAT (national air transport) 247 taken from the portico on the back of the Tulsa Municipal Airport terminal. The aircraft behind it is a Trans-Continental and Western Airlines (TWA) Lockheed Vega. The photograph below shows another NAT 247, but this view was taken from the runway looking back at the art deco terminal. (TASM, courtesy Tulsa Airport Authority.)

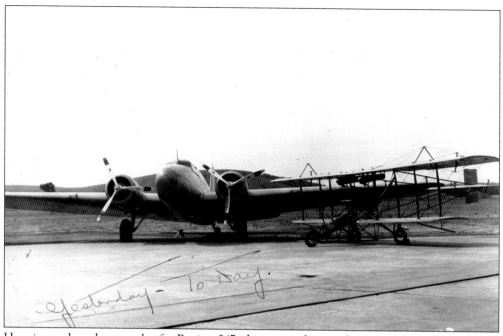

Here is another photograph of a Boeing 247, this time taken at the Bartlesville airport sitting next to one of Billy Parker's pusher biplanes. This is one of the later 247s because it has the NACA cowlings that fully enclose the engines. The inscription tells the story that these are "yesterday" and "today." (TASM, courtesy Bob Buckingham.)

Phillips Petroleum's aviation department attracted many early pilots who were looking for the latest and greatest aviation fuel. Here Billy Parker (left) and Wiley Post (right) talk with Laura Ingalls in front of her Lockheed Orion. Ingalls won the Harmon Trophy in 1934 for flying her Orion from Mexico to Chile over the Andes Mountains to Rio, Cuba, and back to New York. (TASM, courtesy Conoco Phillips.)

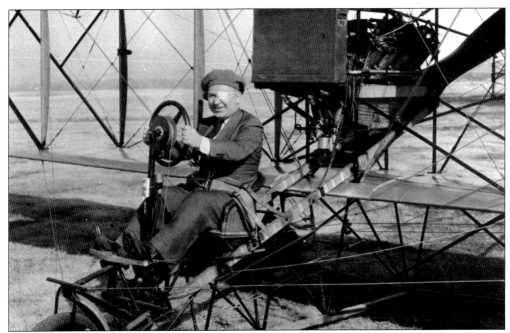

Post worked very closely with Phillips Petroleum through the 1930s. Frank Phillips was a financial backer on many of Post's high-altitude flights that eventually lead him to discover the jet stream and create the world's first practical pressure suit. Post is shown here sitting in Parker's pusher, wearing his signature white eye patch. (TASM, courtesy Tulsa Airport Authority.)

In 1935, Post lent his name to a small biplane. The aircraft was built in Oklahoma City, and the company's president was listed as Wiley Post. In fact, Post had nothing to do with the design or production of the aircraft. This photograph shows Tulsan John Bouteller pulling the prop through on the Post biplane that he restored in Tulsa. (TASM, courtesy John Bouteller.)

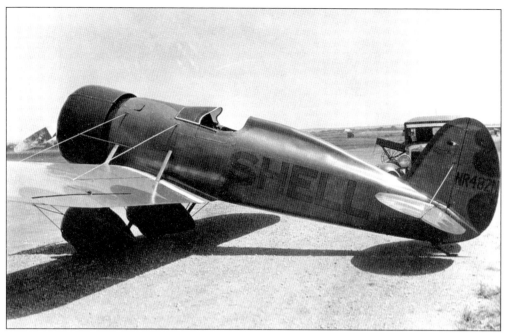

Through the years, Jimmy Doolittle was often at Tulsa Municipal Airport. This is a photograph of the Shell Oil Travel Air Mystery Ship at Tulsa in 1930. This aircraft was flown by Doolittle as well as James Haizlip. Haizlip flew the red and yellow ship in the 1930 Thompson Trophy Race. (TASM, courtesy Tulsa Airport Authority.)

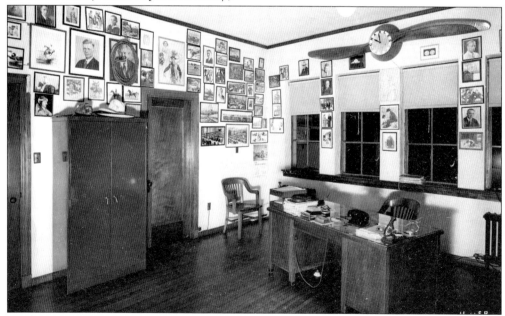

As the years went by at Tulsa Municipal Airport, manager Charlie Short amassed more and more autographed pictures of aviation personalities and their aircraft. Early on, he began to frame each one and hang them on his office walls. Eventually they covered nearly every square inch of wall surface. This is a photograph of his office shortly after the new art deco terminal was finished in 1932. (TASM, courtesy Bob Buckingham.)

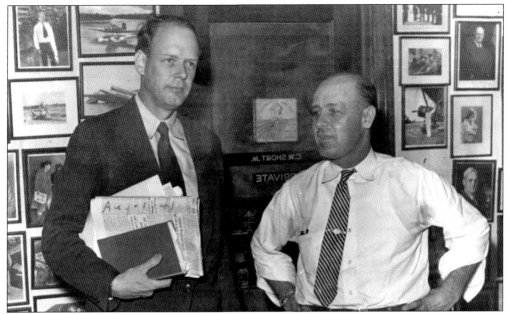

Charles Lindbergh (left) visited Short again in August 1941. Evident in the background are the walls of Short's office. This photograph was no doubt added to the rogue's gallery, as it came to be known, after Lindbergh's departure. Notice that Short's name is backward on his door, indicating that the negative was printed backward; however, the date written on Lindbergh's newspaper is correct. (TASM, courtesy Tulsa Airport Authority.)

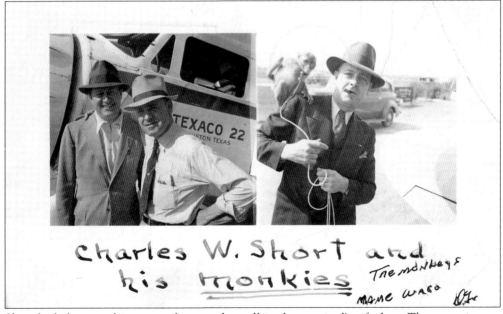

Short had photographic postcards created to sell in the terminal's gift shop. They were images of Tulsa Municipal Airport, and some even included him. This card features a photograph on the left of one of the Texaco corporate aircraft with the unidentified pilot and Short. The right photograph shows Short with Duncan McIntyre's spider monkey, whose name was Waco. (TASM, courtesy Tulsa Airport Authority.)

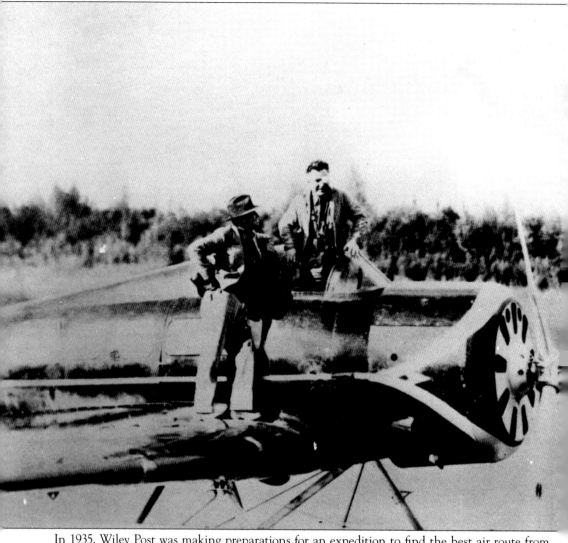

In 1935, Wiley Post was making preparations for an expedition to find the best air route from Alaska to Russia. He invited Will Rogers to go along and write his daily newspaper column en route. The aircraft that they flew was Post's hybrid Lockheed Orion Explorer. Post ordered pontoons for the aircraft so that they could land in the many lakes and bays in Alaska. Post and Rogers were to meet the pontoons in Seattle where they would be installed before they proceeded to Alaska. The floats were late in arriving, and Post, anxious to get underway, bought a pair locally and had them installed on the Explorer. This photograph shows Rogers (standing on the wing) and Post (in the cockpit) at a stop in Alaska. This is one of the last-known photographs of these Oklahoma favorite sons prior to their fatal crash. (TASM, courtesy Tulsa Airport Authority.)

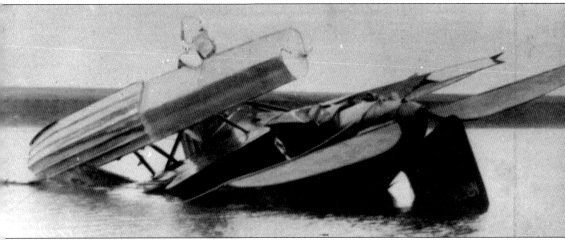

On August 15, 1935, near Point Barrow, Alaska, Post and Rogers got lost in the fog. Post landed on a lake near an Eskimo fishing camp to ask for directions. Satisfied that he had his bearings, they took off and climbed about 150 feet into the air when the engine quit. The Explorer pitched forward and crashed in the lake. Much has been written about the cause of the crash, but it is assured that they were both killed instantly, as the engine was shoved back through the fuselage. Clair Okpeha of the Eskimo fishing camp ran 15 miles to the U.S. Signal Corps station in Point Barrow to report the crash. The bodies were recovered and flown back to the United States by aviator Joe Crosson. The news was flashed around the world, and all of America was in mourning. Aviation had lost two of its most ardent supporters. (TASM, courtesy Tulsa Airport Authority.)

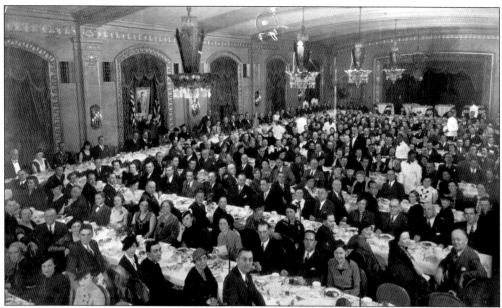

In 1936, after the pain of the loss of Will Rogers and Wiley Post had somewhat eased, a group of Tulsans, including Charlie Short, organized a ceremony to see that Mae Post, Wiley's widow, was personally given the Fédération Aéronautique Internationale Gold Medal (below) that was awarded to Wiley in 1933 after his solo flight around the world. On December 14, 1936, a banquet was held in Wiley's honor in the Topaz Room (above) of the Hotel Tulsa. The attendees included Frank Phillips, Duncan McIntyre, Erle P. Halliburton, Jimmy Doolittle, C. R. Smith, and Billy Parker to name a few. The medal was presented by Frank Phillips, and the event was presided over by Short. (TASM, courtesy Tulsa Airport Authority.)

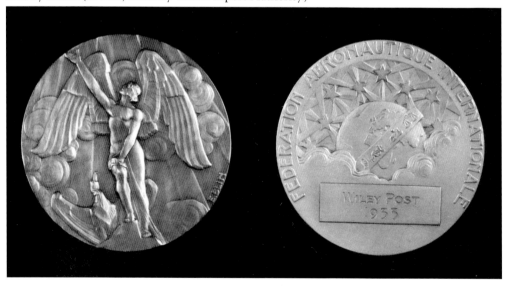

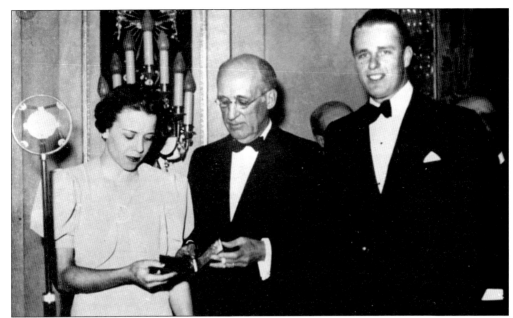

Phillips (center) presents the Fédération Aéronautique Internationale Gold Medal to Mae Post while Elliot Roosevelt, Pres. Franklin D. Roosevelt's son, looks on. Elliot served in the Army Air Corps in World War II. In addition, he accompanied his father as a military aide to the Casablanca meeting of 1943 and again to the Tehran Conference in 1944. (TASM, courtesy Tulsa Airport Authority.)

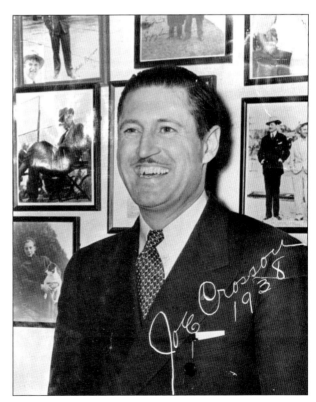

Joe Crosson, who flew the bodies of Will Rogers and Wiley Post back to the United States after their crash in Alaska, visited Short once again in 1938. He is seen here, in happier times, inside Short's office. Notice that the photograph over his left shoulder is of him standing next to Will Rogers. (TASM, courtesy Tulsa Airport Authority.)

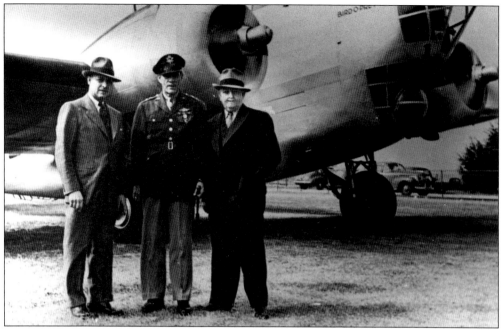

This Douglas B-18, *Bird-O-Prey XV*, was Gen. Clarence Tinker's personal mode of transportation. Tinker, of Osage Indian descent from near Hominy, was the first general to die in World War II. Tinker is shown in the middle with Charlie Short on the left. (TASM, courtesy Tulsa Airport Authority.)

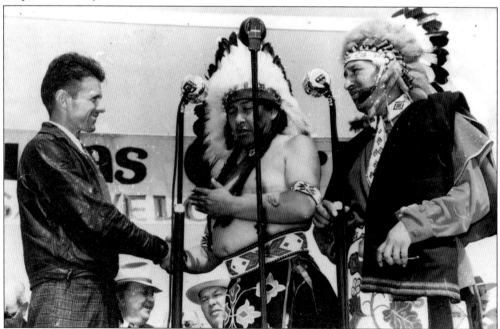

In 1938, Douglas "Wrong Way" Corrigan landed at Tulsa Municipal Airport. Corrigan (left) was given a hero's reception, and he was given a Native American war bonnet and made an honorary chief of the Otoe tribe by Chiefs Joe Shunantona (center) and Frank Brown (left). He was to be known thereafter as "Chief Wrong Way." (TASM, courtesy Tulsa Airport Authority.)

Four

EXPANSION, TRAINING, AND PRODUCTION

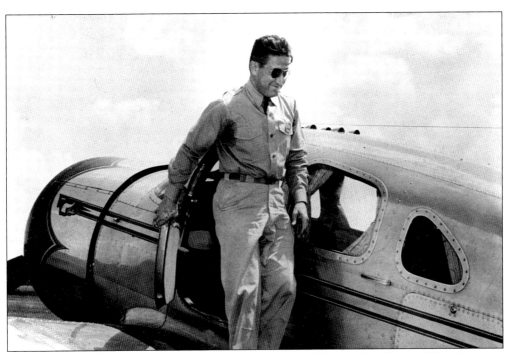

As war clouds formed in Europe, Pres. Franklin D. Roosevelt formed the Civilian Pilots Training Program (CPTP) in 1938 and suggested in 1940 that America build an Arsenal of Democracy to supply the weapons of war to Europe. Spartan School of Aeronautics was invited to attend a conference on pilot training in 1938. W. G. Skelly sent Capt. Maxwell Balfour to attend the conference. He is pictured here with his personal transport, a Spartan Model 7-W Executive. (TASM, courtesy Tulsa Airport Authority.)

Initially Spartan School of Aeronautics was equipped with the antiquated Consolidated PT-3A. The aircraft had only five instruments in the cockpit. They originally flew into Tulsa in 1939 with Spartan's first 13 instructors from Randolph Field in Texas. Thirteen more PT-3s arrived shortly before training started in July. Eventually the school transitioned to the Fairchild PT-19. (TASM, courtesy Tulsa Airport Authority.)

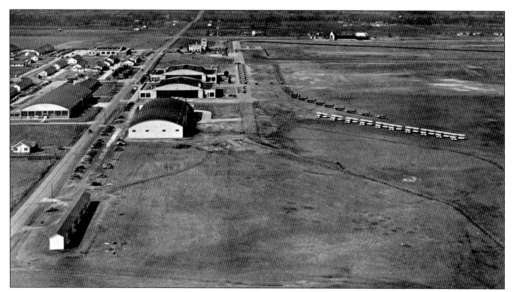

This view looks west across Spartan School of Aeronautics. On the flight line can be seen a lineup of PT-17 Stearmans (light-colored aircraft) and several groups of PT-19s. In the foreground can be seen the engine test cells, and in the left background are the various classrooms and the Spartan cafeteria across the street from the terminal. (TASM, courtesy Spartan College of Aeronautics and Technology.)

Due to the rapid buildup of training schools as the Army Air Corps prepared for war, Spartan School of Aeronautics found that it did not have the facilities in Tulsa to train all the cadets required. As a result, Capt. Maxwell Balfour contracted to build facilities at Muskogee's Hatbox Field. Balfour enlisted the aid of Jay Gentry to help get the facility built. (TASM, courtesy Spartan College of Aeronautics and Technology.)

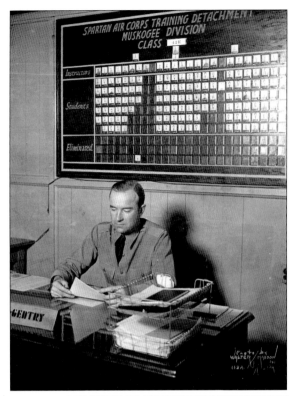

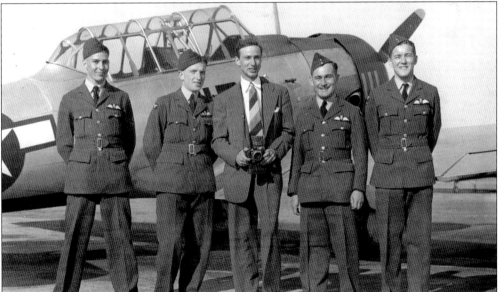

Even before America entered the war, the government was bringing British troops into Oklahoma for flight training. Two of the 10 British Flying Training Squadrons established in the country were located in Oklahoma. Spartan established No. 3 British Flying Training Squadron in Miami. These Royal Air Force cadets are standing in front of a North American AT-6 Texan. From left to right are cadets Phil Williams and A. T. Jenkins, Spartan instructor Wayne T. Saft, and cadets J. S. Jackson and G. A. Paton. (TASM, courtesy Phil Williams.)

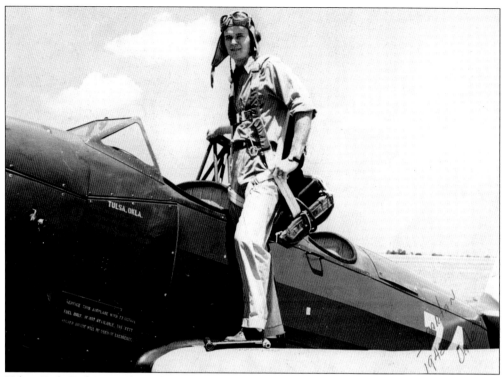

Tulsan Dale Frakes stands on the wing of a Fairchild PT-19 at Spartan School of Aeronautics. He is wearing his seat parachute, ready for any emergency. Frakes went on to fly corporate aircraft after the war, flying for Gulf Oil, SunRay DX, and Warren Petroleum. Notice the inertial starter crank lying at his feet on the wing. This was used to crank a flywheel that would then start the engine when engaged. (TASM, courtesy Tulsa Airport Authority.)

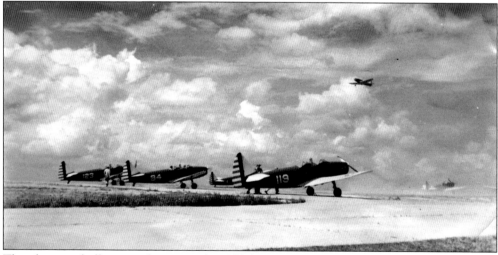

This photograph illustrates the reason that Oklahoma was such a great aviation training ground, with its wide-open prairie and great weather. Oklahoma, California, Kansas, and Texas have more flyable days in a year than any other states. The aircraft are PT-19s, the ship that cadets soloed in before they moved on to the advanced trainer, the AT-6. (TASM, courtesy Spartan College of Aeronautics and Technology.)

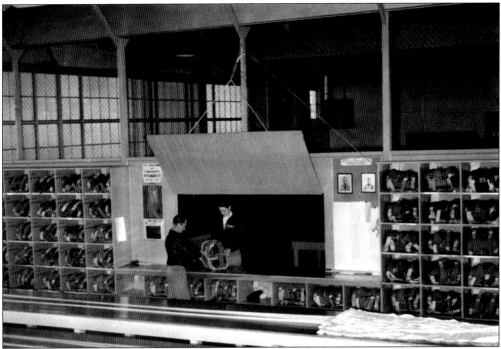

The Spartan parachute department was a very busy place during the war. Each cadet was required to wear a parachute on every flight. Each of those parachutes had to be opened every 60 days, hung in the parachute loft for 24 hours, and examined for defects and airworthiness with a record kept on each parachute. There were three parachute riggers, Bob Buckingham (right), Carl Hall (left), and Dale Frakes (not pictured). (TASM, courtesy Bob Buckingham.)

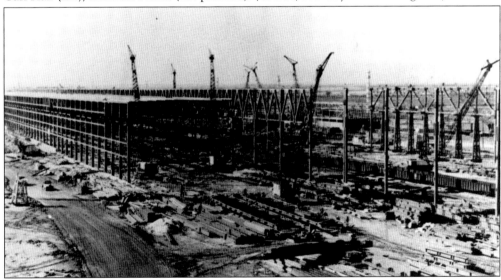

When it came to the attention of the city fathers that the war department planned to build four aircraft manufacturing plants in the middle of the country, they started a campaign to get the ear of every congressman and senator that would listen to them about locating one in Tulsa. After much politicking and many flights to Washington, the answer was yes. Ground was broken on air force plant No. 3 on May 2, 1941. (TASM, courtesy Boeing Company.)

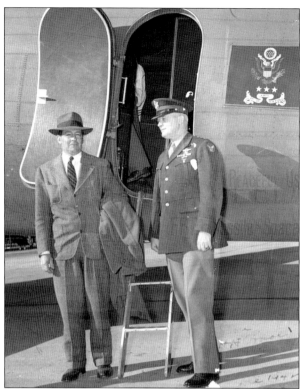

Air force plant No. 3 was to be operated by the Douglas Aircraft Company, and rumor has it that when Donald Douglas found out, he said, "Okies don't know anything about building airplanes, they're just farmers!" True or not, the die was cast. Donald Douglas Jr. and Maj. Gen. Henry H. (Hap) Arnold, head of the Army Air Corps, arrived in Tulsa for dedication ceremonies for the "bomber plant," as the locals had come to call it. (TASM, courtesy Boeing Company.)

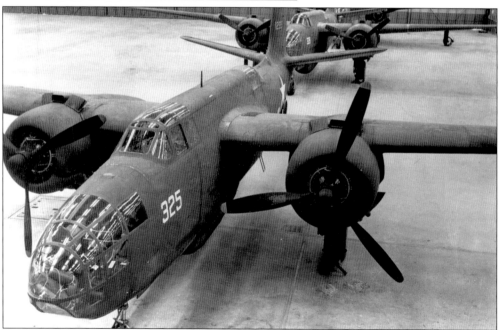

Although slated to perform final assembly on Consolidated B-24s that were to come down Route 66 from Willow Run, Michigan, the bomber plant cut its teeth on modifying several types of aircraft. One of the first to be modified was the Douglas A-20 Havoc, which was used for ground attack. (TASM, courtesy Boeing Company.)

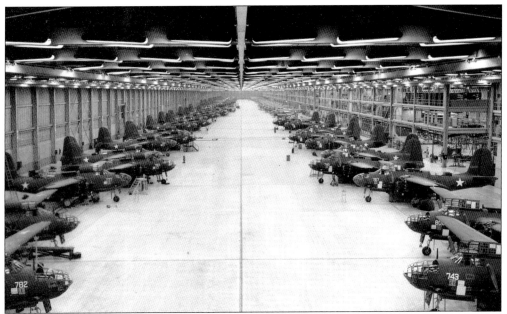

This view of the plant modification line illustrates just how big air force plant No. 3 was. It was nearly seven-eighths of a mile long and 320 feet wide. It is difficult to see in the photograph, but in the foreground are Douglas A-20 Havocs, midway back on the right are North American B-25 Mitchells, and on the left near the rear are the taller tails of Boeing B-17s being converted to YB-40s. (TASM, courtesy Boeing Company.)

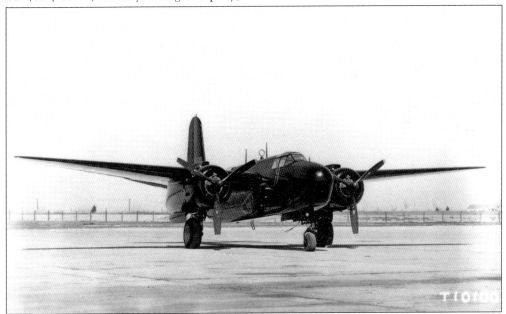

One of the more interesting modifications undertaken at the plant was the conversion of Douglas A-20 Havocs to the P-70 night fighter. The modification included the addition of radar that was fitted in the nose of the aircraft and four forward-firing 20-millimeter cannons mounted in pods on the sides of the fuselage. The program began in December 1943, and 47 aircraft were completed before the program was cancelled. (TASM, courtesy Harry B. Burt III.)

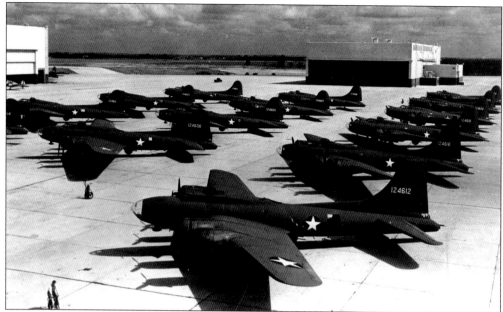

Newly manufactured B-17-Fs sit on the Douglas Aircraft Company ramp at air force plant No. 3 awaiting modification. It was discovered early on that modification of aircraft on the production line slowed the process. It was decided to construct separate modification centers to complete the aircraft away from the production line. Tulsa's modification center was built north of air force plant No. 3. (TASM, courtesy Tulsa Airport Authority.)

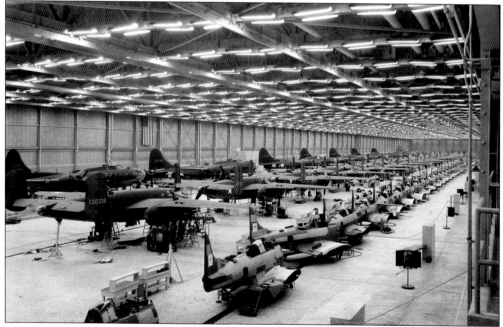

The YB-40 program grew out of a need to create an all-gun bomber escort to protect the bomber formations. It consisted of a chin turret in the nose, an additional top turret, and twin .50-caliber guns in staggered-waist positions. This photograph shows the YB-40 modification along the sidewall of the plant, sharing space with B-25s and A-24s. (TASM, courtesy Boeing Company.)

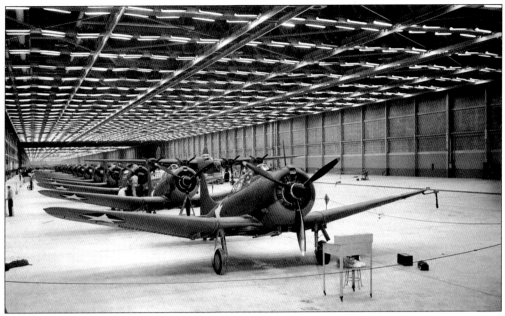

This is a very early photograph inside air force plant No. 3. Finished A-24 Banshees are lined up awaiting test flights and acceptance by the military. In the background is the first completed B-24 for Douglas Tulsa. Being the first assembled, it was the one that the workers cut their teeth on, and it is said that this aircraft was unacceptable to the Army Air Corps. (TASM, courtesy Boeing Company.)

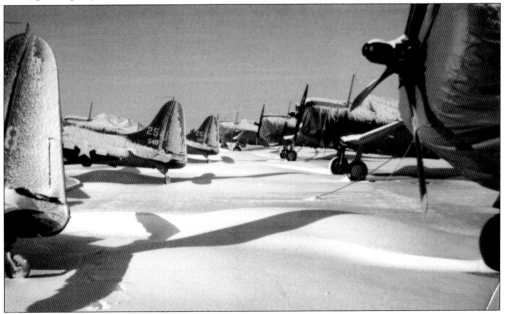

Here is a lineup of A-24s on the Douglas Tulsa ramp awaiting delivery and better weather. The primary difference between the A-24 Banshee and the navy's SBD Dauntless was the deletion of the tail hook on the A-24 and the addition of a pneumatic tail wheel in place of the solid rubber SBD tail wheel. The pneumatic tail wheel can be seen on the first aircraft to the left. (TASM, courtesy Boeing Company.)

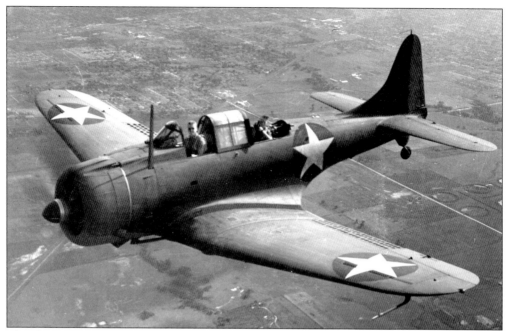

This flying shot of the A-24 over Tulsa clearly shows the beautiful, graceful lines of the aircraft. The A-24 was a dive-bomber that could carry a huge 500-pound bomb under the fuselage. The shackle that swung the bomb clear of the propeller upon release is visible. Downtown Tulsa is in the background. (TASM, courtesy Boeing Company.)

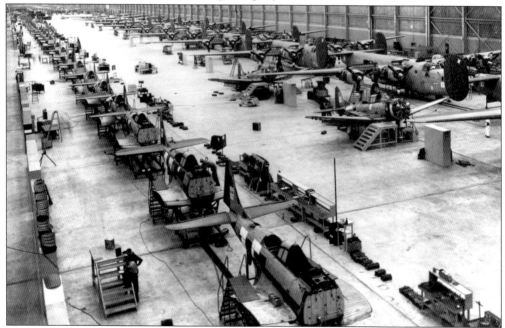

Production is well underway in this photograph. Nearly completed B-24 Liberators are on the line on the right, and A-24s in various states of completion are on the left. Notice that the B-24s move forward on rails installed in the floor of the plant, but the smaller and lighter A-24s are moved forward on wheeled stands. (TASM, courtesy Boeing Company.)

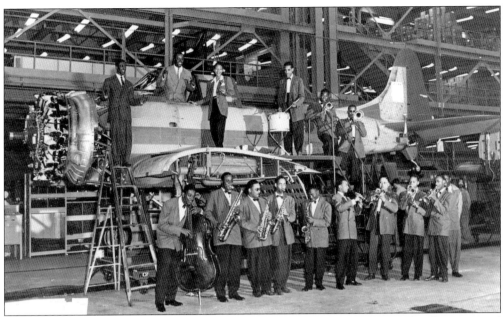

Due to the demands of the military, Douglas employees worked long hours. The plant operated 24 hours, seven days a week. Often management would allow time for a little diversion, such as hosting a bond rally or inviting local musicians in to provide entertainment. This is Tulsa jazz great Ernie Fields and his band performing in and on an incomplete A-24. Fields is in the cockpit of the aircraft. (TASM, courtesy Boeing Company.)

Famous entertainers were often employed to sell war bonds to help pay for the war. This is actress Bette Davis attending a bond rally inside the Douglas Tulsa plant. Tulsa employees often bought enough bonds to pay for an entire B-24 and, in one case, bought an entire squadron of A-26s. (TASM, courtesy Boeing Company.)

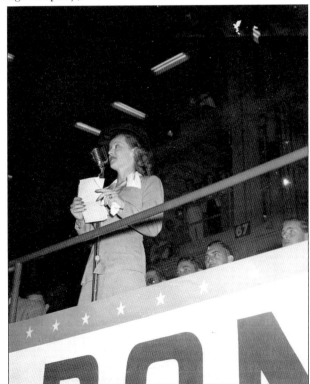

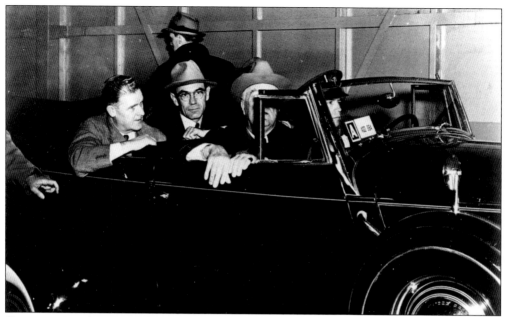

One unexpected visitor, at least to the employees, was Pres. Franklin D. Roosevelt. He arrived on a secret inspection of the plant on April 19, 1943. Arriving with his personal convertible Packard, he was driven slowly through plant inspecting production, often stopping to speak with workers. Notice the A ration stamp on the president's windshield, limiting his use of gasoline and tires. (TASM, courtesy Boeing Company.)

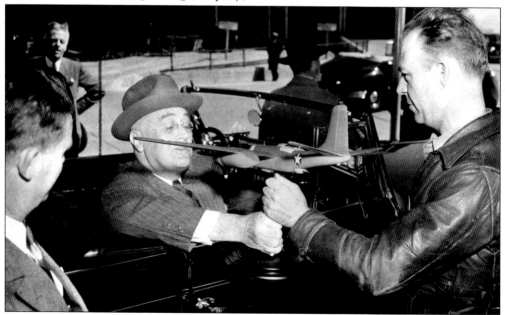

At the end of Roosevelt's visit, he was given a model of the next secret project that the plant would be building, the A-26 Invader. Leadman Otis Smallwood was selected to make the presentation, while Douglas Tulsa general manager Harry O. Williams (left) looks on. According to his son, Smallwood was told not to say anything other than what was rehearsed. (TASM, courtesy Boeing Company.)

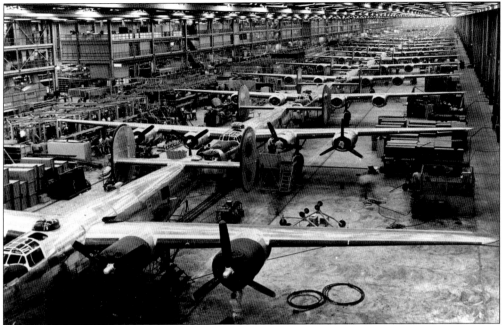

The B-24 line is in full production in this photograph. The area where the A-24 line was has been filled with parts for the B-24s. This view certainly accentuates the length of the bomber plant as B-24s simply fade into the distance. At peak production, Tulsans were producing 12 B-24s per week. (TASM, courtesy Boeing Company.)

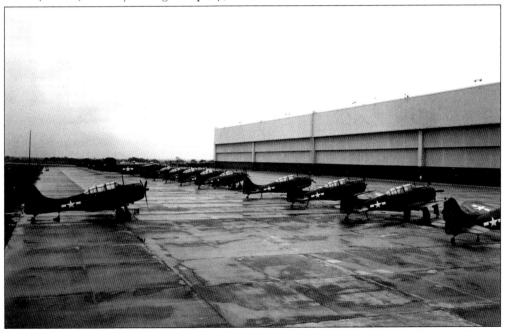

The last of the A-24s and the first of the B-24s to roll off the line await test flights and army acceptance on the ramp of Douglas Tulsa. The building was constructed with no windows to facilitate blackout conditions at night. Notice the huge slide-up doors that allowed less light to filter out at night compared to horizontal sliding doors. (TASM, courtesy Boeing Company.)

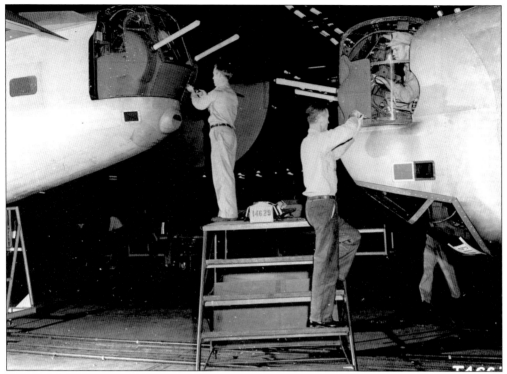

Working on the line, the B-24s are nose to tail. This view shows workers sharing a platform to work on the tail-gun turret (left) and nose-gun turret (right). The mechanized chain drive on the floor that moves the aircraft through the plant is visible. Notice the man inside the nose turret on the right working on the guns. (TASM, courtesy Boeing Company.)

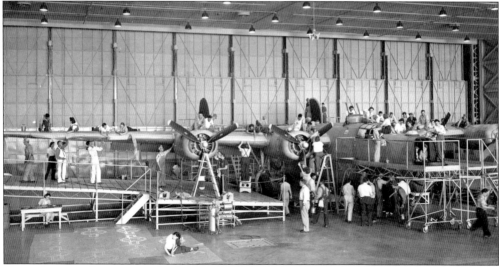

Once the aircraft were completely assembled, they were moved into the paint shop for final painting. In the beginning, the aircraft arrived from Willow Run with the overall olive drab applied to the subassemblies. The paint shop applied the national insignia (notice the masks on the floor) and all the antiglare panels and myriad of stencils. By 1944, the B-24s were being shipped without the olive drab paint. (TASM, courtesy Boeing Company.)

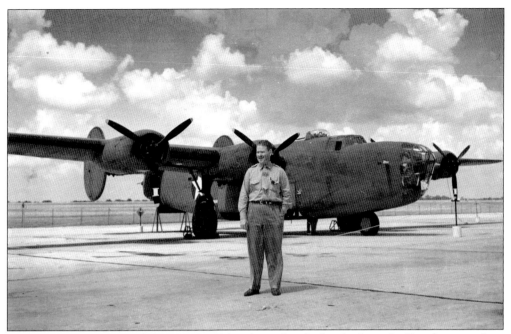

Once aircraft rolled out of the Douglas Tulsa plant, they had to be flown by Douglas test pilots, and then they were flown by Army Air Corps pilots, who accepted or declined them for the military. This is Douglas chief test pilot John Carroll standing in front of what is claimed to be the first B-24 to roll off the line. (TASM, courtesy Boeing Company.)

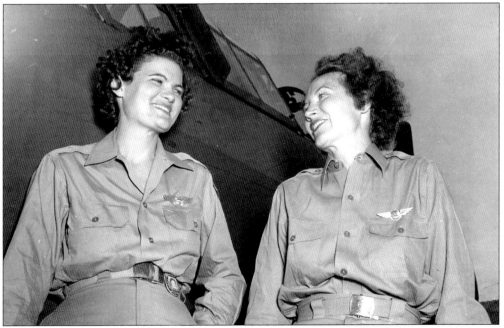

After the aircraft had been accepted by the army inspectors and pilots, they had to be flown to the next phase of the aircraft's life. Sometimes they were flown to another plant for further modification, or they went to a military base for flight-crew training. These are WASPs who flew the aircraft to their next stop. (TASM, courtesy Boeing Company.)

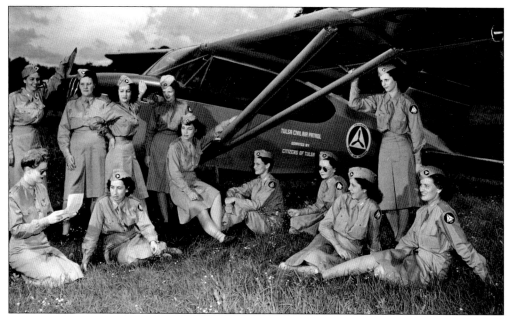

During World War II, the Civil Air Patrol (CAP) made a valuable contribution to the war effort. In coastal regions, it flew antisubmarine missions, unarmed in the beginning and later with bombs. In Tulsa, the CAP performed several duties, including airport security, courier flights, and search and rescue. These CAP cadets are receiving instruction from their lieutenant. (TASM, courtesy Boeing Company.)

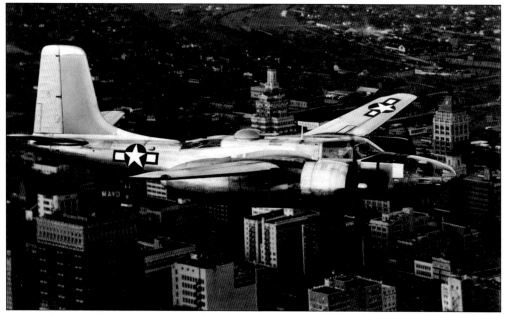

In 1943, Douglas Tulsa was preparing for the next aircraft that it would be called upon to build. The Douglas A-26 Invader was a secret project at the time of Pres. Franklin D. Roosevelt's Tulsa visit, but tooling had already begun for the new attack bomber. Designed to replace the aging A-20 Havoc, the Invader incorporated the latest technology, including remotely operated gun turrets. This view is an A-26 flying over downtown Tulsa. (TASM, courtesy Boeing Company.)

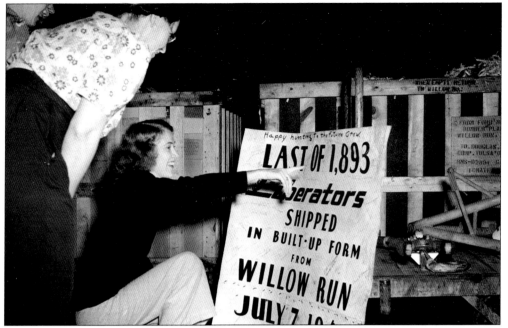

By July 1944, the final B-24 kit was shipped to Douglas Tulsa. The Douglas workers were so proud of how they had contributed to winning the war that they had a bond drive to pay for the final airplane. In honor of the final B-24, No. 952, the plant held a naming contest for the new bomber. The name chosen was *Tulsamerican*. (TASM, courtesy Boeing Company.)

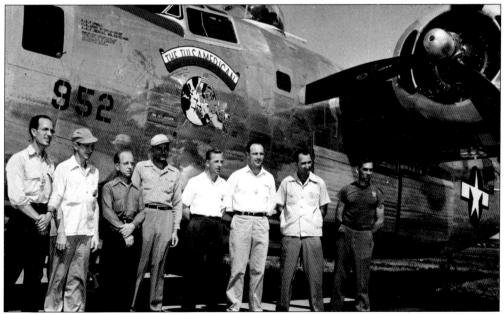

The nose art on the *Tulsamerican* features the Douglas Tulsa mascot, Tulsa Joe, carrying an American flag and a war knife, with the Douglas logo in the background. The name was created by H. W. Addington, and the artwork was designed by Floyd Bridges, both Douglas Tulsa employees. This photograph shows some of the engineers who worked on the *Tulsamerican*. (TASM, courtesy Boeing Company.)

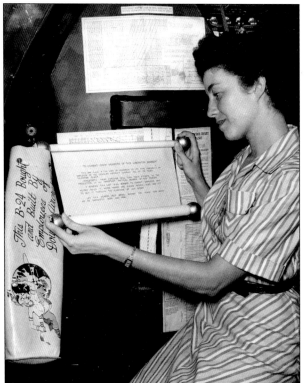

A scroll was created that was signed by all the employees who worked on the *Tulsamerican*. It was then rolled up and placed into a special leather case that was made for it and placed under the pilot's seat. In addition, the aircraft was signed on the outside by all the employees who worked on it. Many wrote their addresses while others wrote best wishes. (TASM, courtesy Boeing Company.)

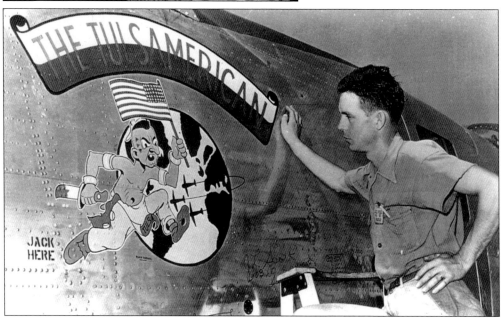

H. W. Addington admires the artwork of the *Tulsamerican*. This photograph shows some of the signatures and sentiments written by the employees. The *Tulsamerican* flew its whole career with this nose art in place. When the bomber reached Italy, many Tulsans received letters from the aircrews and ground crews, letting them know that they had seen the bomber and that it was doing fine. (TASM, courtesy Boeing Company.)

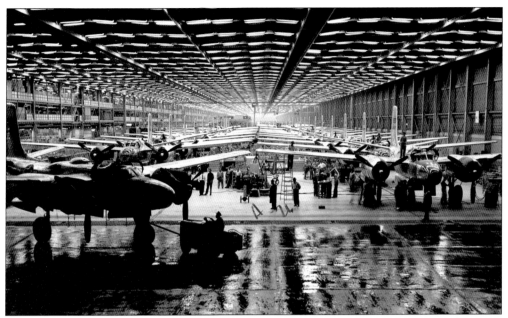

When the Douglas Tulsa employees found out that the *Tulsamerican* was shot down on December 17, 1944, they were not only very sad but also determined. They held a war bond drive and raised enough money to build an entire squadron of the new A-26s to avenge their B-24's death. Here is a rainy night shot of the A-26 line taken through the doors of the bomber plant. (TASM, courtesy Boeing Company.)

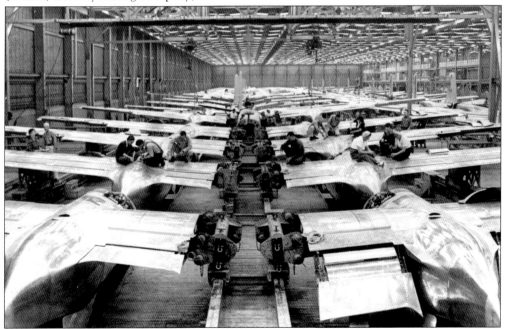

The wing assembly area of the A-26 line shows many "Rosie the Riveters" working on the line. At peak production, over 50 percent of the Douglas Tulsa employees were women. At the end of the Invader program, Tulsans built a total of 615 A-24s, 962 B-24s and 1,343 A-26s. (TASM, courtesy Boeing Company.)

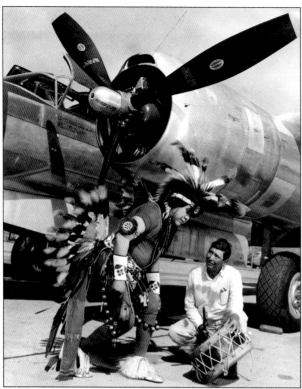

On the occasion of the completion of the 1,000th A-26 Invader, the Douglas management orchestrated a huge celebration at the plant. During that event, many local Native Americans were invited to the ceremony to help them bless the aircraft to ensure happy hunting. This Pawnee fancy dancer and drummer bless the 1,000th A-26, serial number 44-35697. (TASM, courtesy Boeing Company.)

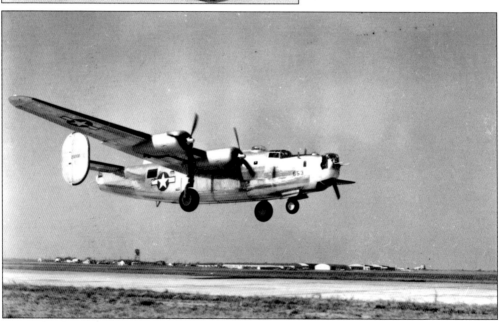

A B-24 lands on the 10,000-foot-long runway at Tulsa Municipal Airport after a test flight. This is No. 653, serial number 42-51131. Each aircraft built was test flown to discover any problems with the aircraft. If problems were found, it was returned for repair. This continued until the Douglas pilot was satisfied. It was then flown by an Army Air Corps pilot, and the process started again. (TASM, courtesy Boeing Company.)

Douglas C-47s were modified at the modification center. This version incorporated a glider pickup bracket. The army devised a way for downed gliders to erect a framework that held their towrope. With the inclusion of the glider pickup bracket, the C-47 could fly low over the downed glider, snag the towrope from the framework, and tow the glider back to an Allied airbase. These modifications began in late 1943. (TASM, courtesy Harry B. Burt III.)

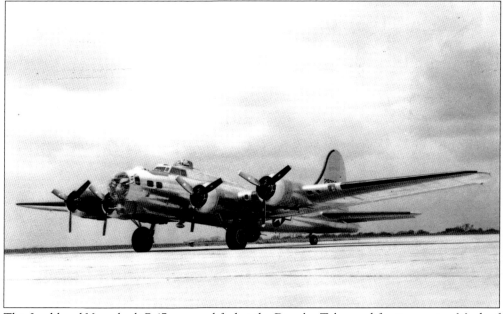

This Lockheed Vega–built B-17 was modified at the Douglas Tulsa modification center. Much of the modification work done in Tulsa included such things as the staggered waist gun positions and installation of the remote-controlled chin turret that were first incorporated into the YB-40. It was these modifications that led to the creation of the much-improved B-17G. (TASM, courtesy Boeing Company.)

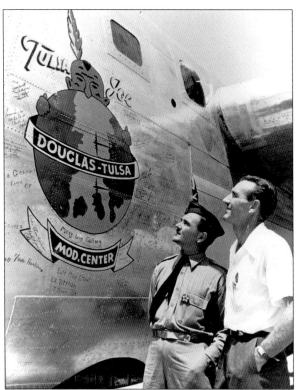

The *Tulsa Joe* was the final B-24 modified at the Douglas Tulsa modification center. As with the *Tulsamerican*, the employees that worked on it signed their names on the exterior of the airplane, and the plant's mascot, Tulsa Joe, was incorporated into the nose art. The last aircraft type worked on at the modification center was Northrop P-61 Black Widows of which no photographs remain. All that is left is an accident report when one caught fire. (TASM, courtesy Boeing Company.)

Douglas Tulsa plant workers listen intently to a special message that was broadcast throughout the plant announcing victory in Europe on May 8, 1945. Of course the war was not over because it still raged on in the Pacific. It took another three months of bitter fighting before the Japanese surrendered on August 14, 1945. (TASM, courtesy Boeing Company.)

Five

THE COLD WAR AND THE FINAL FRONTIER

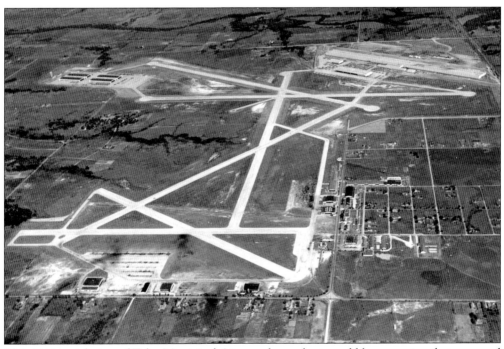

This 1945 aerial view of Tulsa Municipal Airport shows the incredible expansion that occurred during World War II. In the foreground is the commercial and civil side of aviation, with the terminal and hangars. The Oklahoma Air National Guard's hangar (black-roofed building at far left) was completed in 1942. Spartan School of Aeronautics has doubled in size (dark-roofed buildings near center), and the Douglas plant (upper right corner) has expanded and added runways to handle the heavy bombers. (TASM, courtesy Tulsa Airport Authority.)

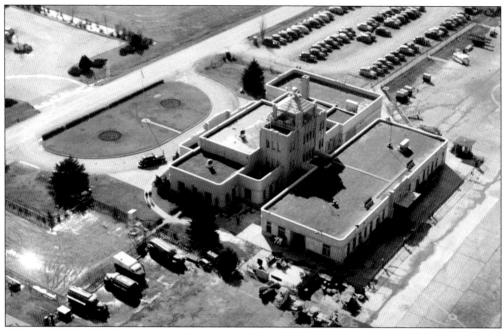

The old art deco terminal underwent expansion during World War II. An annex was added to the back to accommodate additional airline counters, and the structure was expanded to the west for more staff offices. It underwent additional changes over the next decade that eventually lead to it being replaced with a new terminal. (TASM, courtesy Tulsa Airport Authority.)

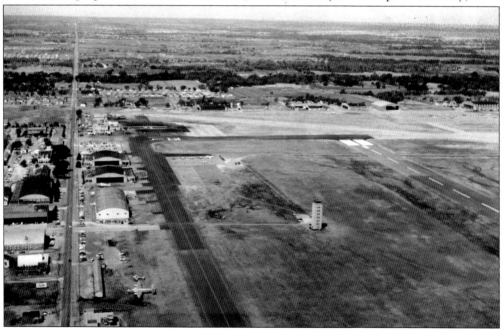

The postwar commercial side of Tulsa Municipal Airport is beginning to show its age. This view shows the new tower that was built in 1942. Once the bomber plant was completed, it became obvious that the tower could not see operations there. It was then put on a skid and moved 100 yards to the east. (TASM, courtesy Tulsa Airport Authority.)

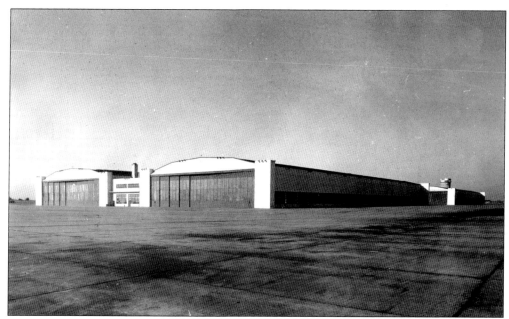

By the end of 1945, the Douglas modification center sat idle and served as a storage area for Douglas Aircraft Company. This was not the case for long because American Airlines was gearing up for a postwar travel boom, and it was looking for a central location to move its maintenance center from Ithaca, New York. A lease was signed on January 10, 1946, and the move began. (TASM, courtesy Tulsa Airport Authority.)

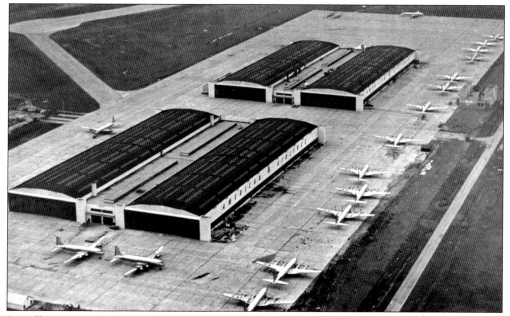

Initially using only the south two hangars (foreground), American Airlines was ready for its first roll out in June 1946. There are 17 DC-6s in this photograph that are awaiting a vent modification. After a series of fires that grounded all DC-6s, the Tulsa base made the vent modifications, returning all DC-6s back to service in five months. (TASM, courtesy Tulsa Airport Authority.)

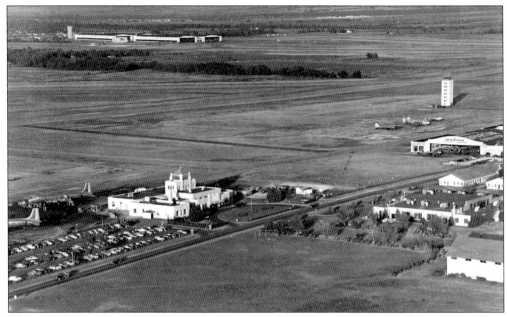

This view from the late 1950s shows the American Airlines maintenance and engineering base in the background beyond the terminal. Two American DC-6s sit at the terminal awaiting boarding passengers and fuel. Airline travel was continuing to grow as American Airlines hoped. As the base grew, additional office space and hangar space was necessary. (TASM, courtesy Tulsa Airport Authority.)

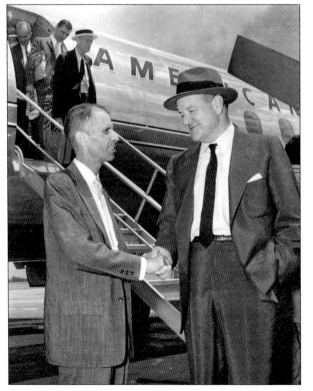

On July 6, 1955, airport manager Charlie Short died. For 27 years, he guided the airport through a depression, overwhelming growth, and a world war. Perhaps the coming jet age was not to his liking. His replacement was Pat Combs. Combs (left) is shown here with another stalwart, C. R. Smith. Smith ran American Airlines from 1934 to 1968 and again from 1973 to 1974. The aircraft is the Lockheed Electra. (TASM, courtesy Tulsa Airport Authority.)

In 1948, Israel became a nation when it gained its independence from the United Kingdom. In 1949, Israel sent 42 young men to Spartan School of Aeronautics to learn how to work on airframes and engines. In 1950, those young men returned to Israel and helped build an exact copy of Spartan School of Aeronautics in the city of Haifa. They went on to train the future mechanics of the Israel Air Force. (TASM, courtesy Bob Golan.)

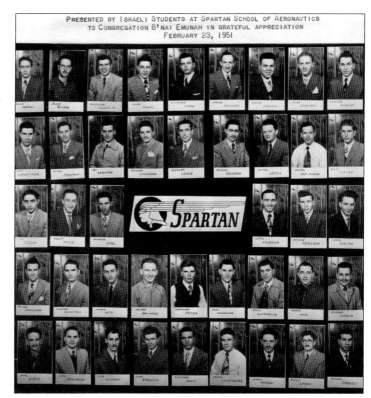

As airliners became larger, it was necessary to increase the size of the hangars where they were serviced. American built this 17.5 million-cubic-foot hangar to service the larger jets, such as the Boeing 747 and the Douglas DC-10. Known as Hangar 5 when it was built, it was the first hangar in the world designed to service jumbo jets. Today the Tulsa American Airlines maintenance base is the largest of its kind in the world. (TASM, courtesy Tulsa Airport Authority.)

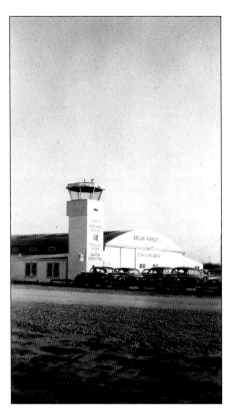

As Tulsa Municipal Airport grew, other small airports were either expanded or changed hands through the years. The original Garland-Clevenger School of Aeronautics at Fifty-first Street and Sheridan Road became Brown Airport with expanded facilities, including a control tower and a café. Duncan McIntyre ran Brown Airport for a period of time before he moved to California to work for Lockheed in 1940. (TASM, courtesy Tulsa Airport Authority.)

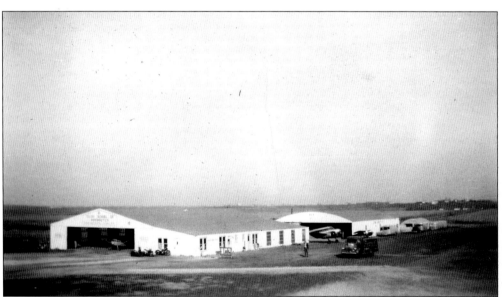

These hangars at Brown Airport were located along the east side of Sheridan Road. Various businesses at Brown Airport offered flying services, airplane rentals, flight instruction, aerial photography, flights around town, and banner towing. Today the entire airport is covered with houses, churches, and even a light industrial park on the north end. (TASM, courtesy Tulsa Airport Authority.)

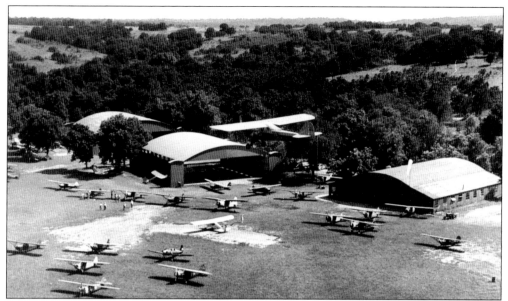

Commercial Airport, located at Sixty-first Street and Yale Avenue, was managed by longtime Tulsa pilot Marvin Sullenger. Future Tulsa Municipal Airport manager Pat Combs operated the Lee and Combs flying service with partner Thomas Lee. When the airport was closed in the 1950s to build a housing addition, the north–south runway was retained as a residential street. As a result, Urbana Street is the widest residential street in Tulsa. (TASM, courtesy Marvin Sullenger Jr.)

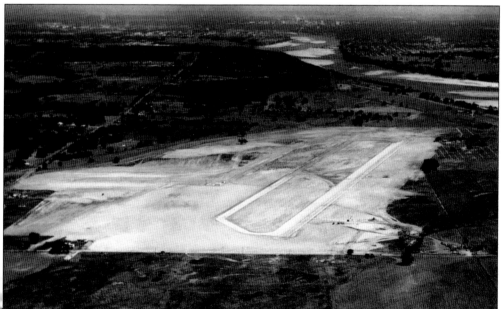

With the increased usage at Tulsa Municipal Airport, the city started looking for a site to build a reliever airport. A 700-acre site near the town of Jenks was chosen. On July 4, 1958, Riverside Airport was dedicated exactly 30 years after Tulsa Municipal Airport was opened. This view shows the airport under construction. Notice its proximity to the Arkansas River. (TASM, courtesy Tulsa Airport Authority.)

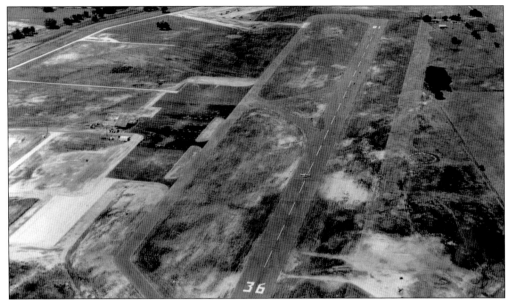

This photograph shows Riverside Airport shortly after its opening. While the airport is in use with an airplane on the runway, there is very little infrastructure built at this point. It was considered an uncontrolled airport at this time due to the lack of a control tower. Once Spartan School of Aeronautics relocated its flight training department from Tulsa Municipal Airport to Riverside on January 9, 1967, the airport really began to expand. (TASM, courtesy Tulsa Airport Authority.)

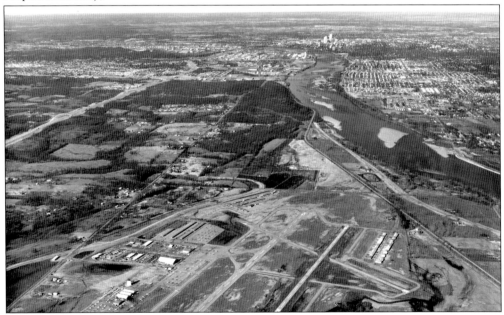

This is a more recent photograph of what has become R. L. Jones Jr. Airport. Apparent is the continued development of the airport with private hangars springing up on the east and the northwest. Jones Riverside, as it is referred to by locals, is today the busiest airport in the state, with several flight schools and many corporate aircraft based there. Downtown Tulsa can be seen in the background. (TASM, courtesy Tulsa Airport Authority.)

Tulsa was the host of the International Petroleum Exposition, which began in 1923 and continued each year until its demise in 1979. Charlie Short made sure that Tulsa's front door, Tulsa Municipal Airport, was a welcoming place for the thousands of attendees to the exposition. The miniature oil derrick was always installed over the airport-side portico to guide visitors to the terminal. Exhibits on the street side of the terminal (below) were erected as well. These included portable oil rigs, oil field equipment, trucks, and airplanes. Short is at the gate (near the left post) to personally greet arriving guests. With him are other members of the airport board, including R. L. Jones Jr. (behind Short) and N. G. Henthorne (on Short's left). (TASM, courtesy Tulsa Airport Authority.)

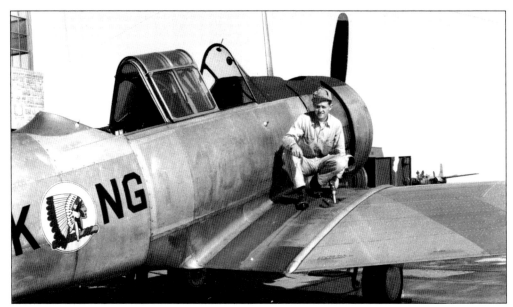

The Tulsa unit of the Oklahoma Air National Guard was officially recognized by the federal government in 1941 as the 125th Observation Squadron. It served in Europe during World War II as the 125th Liaison Squadron. After the war, the unit was redesignated as the 125th Fighter Squadron. This photograph shows an AT-6 beside the recently completed hangar. Notice the Native American head in place of the national insignia. (TASM, courtesy Tulsa Airport Authority.)

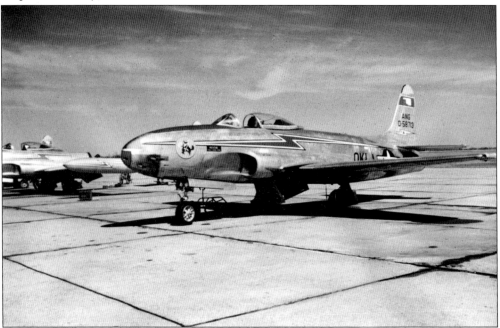

In 1957, the unit was again redesignated as the 125th Interceptor Squadron. As a transition aircraft, the unit flew the Lockheed P-80 Shooting Star, an airplane that actually flew near the end of World War II. Notice the Bucky Beaver insignia on the nose of the aircraft. Bucky Beaver has been the mascot of the unit since its inception in 1940. (TASM, courtesy Jack Seay.)

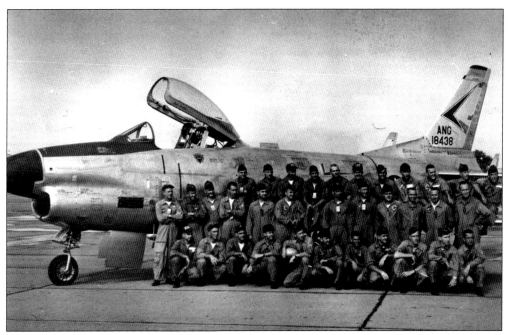

Soon the 125th Interceptor Squadron received the North American F-86D. This photograph shows one of the aircraft as the squadron received it prior to being repainted in the Oklahoma Air National Guard markings. Someone on the pilots' left must have said something funny, as they are all looking in that direction and laughing. (TASM, courtesy Jack Seay.)

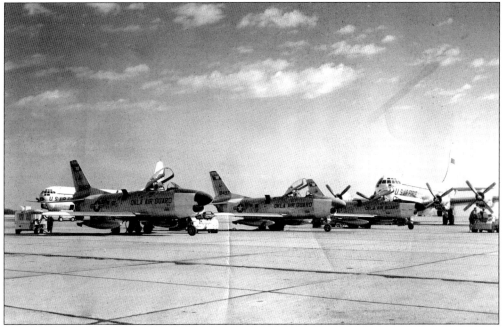

In 1957, the unit was flying the North American F-86D fighters. Three of the F-86 Dogs, as they were affectionately called, can be seen on the air guard ramp. Notice the outline of the state of Oklahoma on the vertical stabilizer. In the background are two C-97s. (TASM, courtesy Tulsa Airport Authority.)

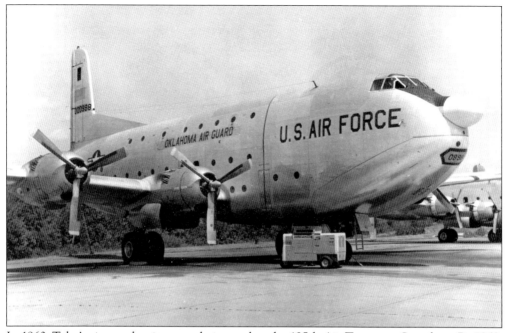

In 1960, Tulsa's air guard unit was redesignated as the 125th Air Transport Squadron. By 1968, it had transitioned from the C-97 to the C-124. This C-124 sits on the ramp at the air guard base at Tulsa Municipal Airport. For pilots used to flying fast jets, the C-124 was quite a letdown. (TASM, courtesy Tulsa Airport Authority.)

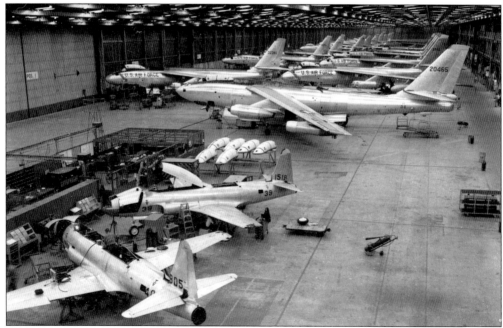

Douglas Tulsa was closed in 1946 but was reopened in 1951 when Douglas Aircraft Company was chosen to help build the Boeing B-47 Stratofortress. While tooling up for production, Douglas Tulsa received 54 B-47s for modification. Some of these are seen in this photograph, along with two Lockheed T-33 trainers undergoing modification. (TASM, courtesy Boeing Company.)

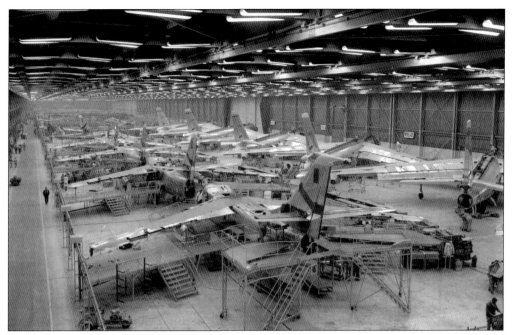

While Douglas was building B-47s, an order was received to build the new Douglas RB-66. Simultaneous lines were created inside the plant so that the RB-66 program could be accommodated. On the right is the B-47 line, and the RB-66 line is on the left. (TASM, courtesy Boeing Company.)

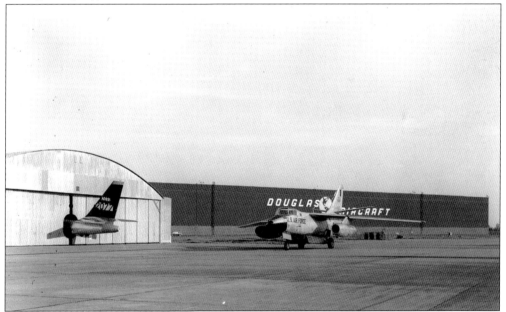

An RB-66 rolls past air force plant No. 3 on its way to the runway for a test flight. The small round-top hangar on the left is what was referred to as a TP hangar, or temporary hangar. Not having room to build large hangars to house the B-47s for maintenance, this hangar allowed the bulk of the aircraft to be inside where the mechanics could work out of the weather. (TASM, courtesy Boeing Company.)

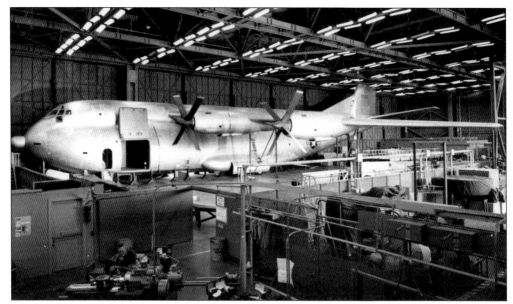

Even as the B-47 program was coming to a close and the RB-66 program was ongoing, Douglas Tulsa was preparing to design, engineer, and manufacture the giant Douglas C-132. As part of the preliminary design phases, a full-size wooden mock-up was built in the plant. The aircraft was so large that they could only build it with the port wing, port horizontal, and half of a vertical stabilizer. The program was cancelled before it really began. (TASM, courtesy Boeing Company.)

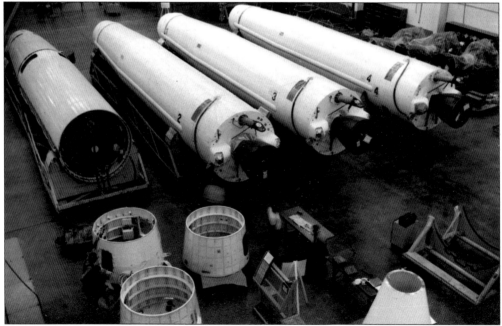

Despite the letdown of the cancelled C-132 program, Douglas Tulsa soon received a contract to modify Thor ICBMs for England. Four of the missiles are shown here in various stages of modification. This work served to prepare Douglas Tulsa for the Delta program that was developed beginning in 1958. (TASM, courtesy Boeing Company.)

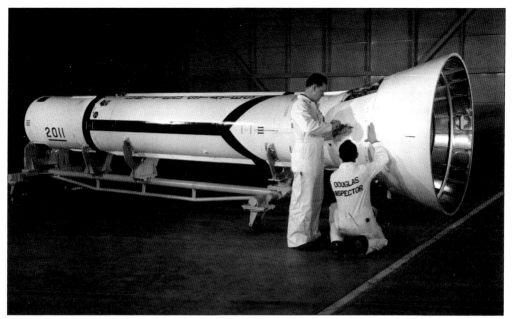

After the launch of Sputnik in 1957, the newly created NASA approached Douglas Tulsa to see if it could create a rocket to put something into orbit fast. Utilizing the Thor as the first stage and adding two more stages, Tulsa engineers created what became known as Delta. Once the program was proven, it was moved to California. This photograph shows Douglas Tulsa technicians working on the second stage of the Delta rocket. (TASM, courtesy Ray Bachlor.)

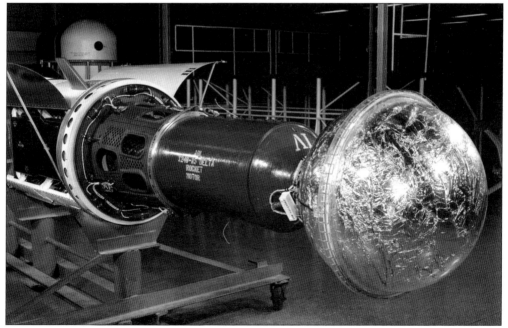

This is a photograph of the third stage of the Delta rocket. This stage housed the payload portion of the rocket and the spin-stabilization platform. According to Tulsan Ray Bachlor, assistant project engineer on the Delta program, Tulsa became, much by accident, a major player in the unmanned space program. (TASM, courtesy Ray Bachlor.)

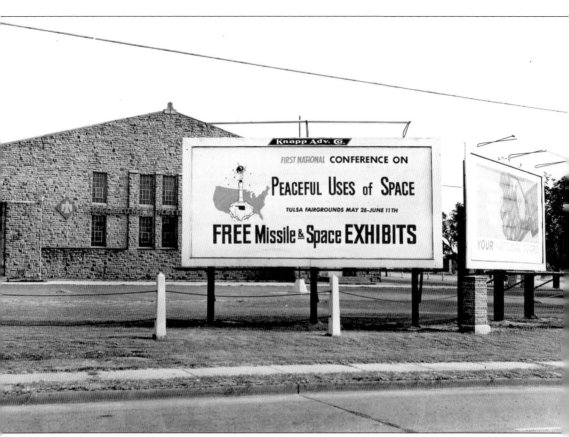

On May 25, 1961, Pres. John F. Kennedy addressed Congress and presented a challenge to put a man on the moon and return him safely to earth by the end of the decade. The next day, the first Peaceful Uses of Space conference was held in Tulsa. Scientists and engineers from around the world came to Tulsa for two days to discuss the peaceful uses of space. The Soviet Union sent its German scientists, and the United States sent its German scientists, including Wernher von Braun. This sign in front of the National Guard armory on Fifteenth Street announces the dates for the public portion of the conference. The event drew thousands of Tulsans to the fairgrounds to see what the future of space exploration held in store for them. Schools bused students to the fairgrounds by the hundreds to view the exhibits and actual space hardware. (TASM, courtesy Boeing Company.)

Rocket scientist Wernher von Braun (right) talks with Oklahoma senator Robert S. Kerr during the first Peaceful Uses of Space conference. The model behind them is the Saturn 1 rocket. It was the power of Kerr and his friendship with Vice Pres. Lyndon B. Johnson, the chairman of the National Aeronautics and Space Council, that brought so much space program work to Oklahoma. (TASM, courtesy Tulsa Chamber of Commerce.)

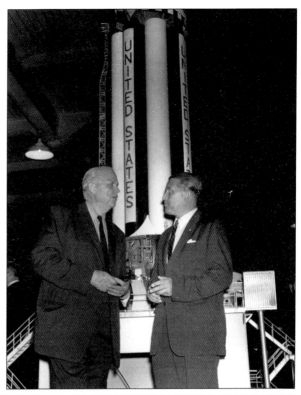

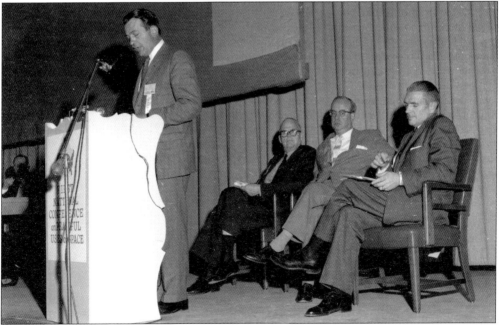

Donald Douglas Jr. addresses the first Peaceful Uses of Space conference. On the platform behind Douglas are, from left to right, Kerr, unidentified, and Harold C. Stuart (conference chairman). Stuart was married to W. G. Skelly's daughter and was the former assistant secretary of the air force. (TASM, courtesy Tulsa Chamber of Commerce.)

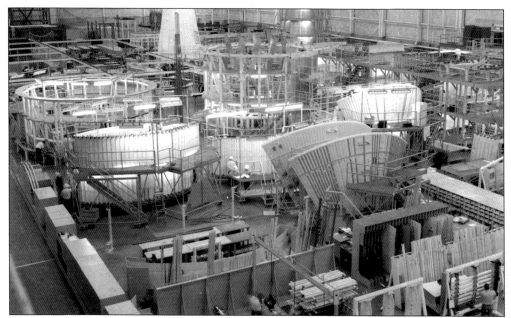

In 1962, North American Aviation negotiated with Douglas to occupy 270,000 square feet of space in air force plant No. 3. Initially the company was manufacturing components for Minuteman missiles but soon was involved in fabricating panels for the Saturn V rocket that took Americans to the moon. This is a view of the Saturn V assembly area in the plant. (TASM, courtesy Boeing Company.)

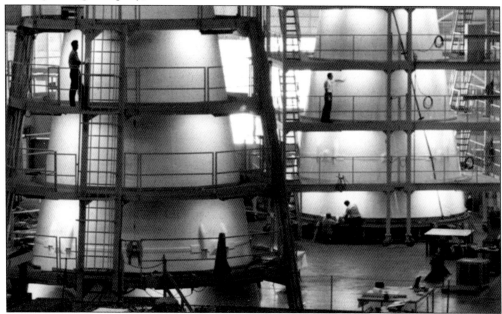

This photograph shows the Saturn Lander Adapter assembly area inside air force plant No. 3. This is the segment of the Saturn V rocket assembly that carried the lunar lander to the moon. Early on, techniques were devised to transport the Saturn Lander Adapter to Cape Canaveral slung underneath a helicopter. Before long, the Pregnant Guppy became operational, and most hardware was flown in it to the cape. (TASM, courtesy Boeing Company.)

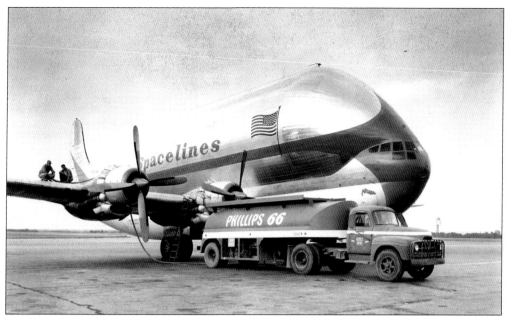

Known as the Pregnant Guppy, this highly modified Boeing C-97 was developed to carry the huge portions of the Saturn V rocket. It was operated by Spacelines, which had one customer: NASA. The Pregnant Guppy sits on the ramp at Tulsa and takes on fuel as it waits for its next piece of the Saturn V rocket. Notice the Tulsa control tower in the right background. (TASM, courtesy Boeing Company.)

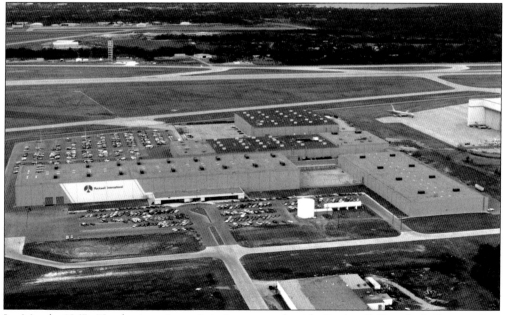

In March 1967, North American Aviation merged with Rockwell Standard Corporation, creating North American Rockwell. By 1973, there was a new name on the building at Tulsa International Airport: Rockwell International. This aerial view shows the Rockwell building, American Airlines to the right, and the newest Tulsa tower in the background. (TASM, courtesy Boeing Company.)

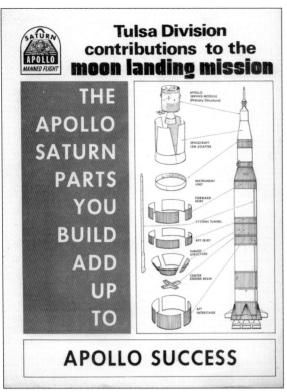

This North American Rockwell poster shows the sections of the Saturn V rocket that were built in Tulsa. In addition to the actual rocket sections, many pieces of the ground-handling equipment were built at the plant along with large-wheeled transporters for the stages of the Saturn V. (TASM, courtesy Boeing Company.)

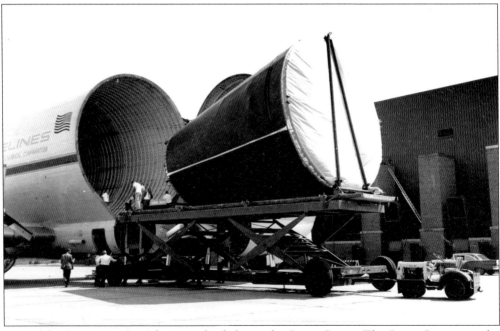

One of the Saturn Lander Adapters is loaded into the Super Guppy. The Super Guppy was the second version of the Guppy line. While the Pregnant Guppy was equipped with piston engines, the Super Guppy was equipped with turbine engines. Note the large scissor platform that was developed for loading the Saturn V sections. (TASM, courtesy Boeing Company.)

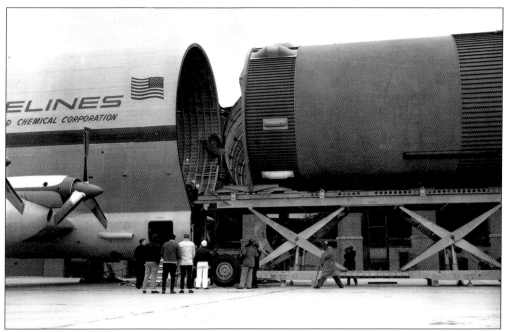

Another section of the Saturn V enters the giant maw of the Super Guppy. Notice the hinge area of the section of the Super Guppy that pivots away. Since the entire cockpit separates from the fuselage, all the controls for the flying surfaces, electrical cables, and hydraulic hoses must pass between the hinges on the left side of the fuselage. (TASM, courtesy Boeing Company.)

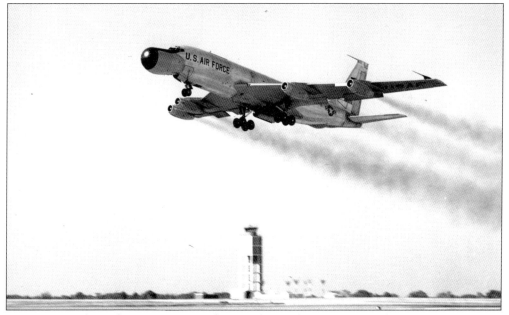

In 1966, Douglas Tulsa was contracted to modify eight C-135s into the EC-135Ns. Known as the A/RIA, or Apollo Range Instrumented Aircraft, the aircraft were to be used to keep NASA in constant contact with the Apollo missions. During the *Gemini 12* flight, the A/RIA became the first aircraft to communicate directly with an orbiting spacecraft. (TASM, courtesy Boeing Company.)

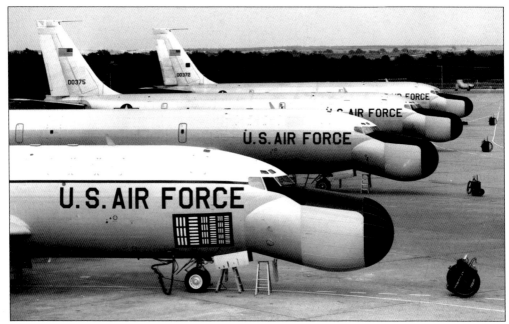

Four of the A/RIA aircraft sit on the ramp at Douglas Tulsa. This photograph offers a good view of the bulbous nose of the aircraft. The nose is an 8-foot-wide, 10-foot-long radome housing a large dish-shaped antenna for tracking and locking onto a spacecraft and sending and receiving data and voice communication. (TASM, courtesy Boeing Company.)

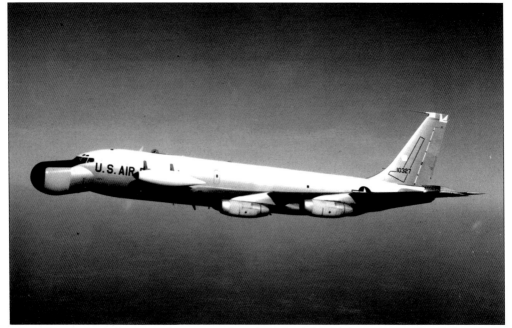

This EC-135N has a large aerodynamic pod on the side of the fuselage. Originally all the A/RIA aircraft were to have this pod that housed a high-powered camera. It was thought that the camera could actually take photographs of the spacecraft either in orbit around earth or the moon or in transit. It was decided to delete the pod in actual use. (TASM, courtesy Boeing Company.)

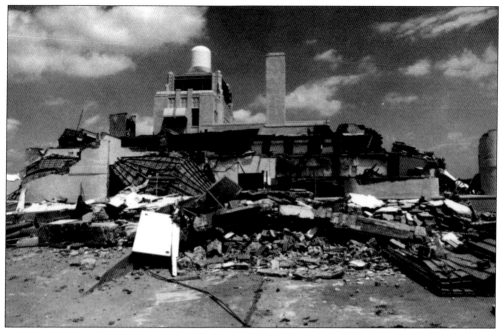

In 1969, the old art deco terminal building was unceremoniously torn down (above). By this time, the terminal was enlarged, reconfigured, and redesignated as the general aviation terminal after the new airline terminal was constructed in 1961. As the bulldozers ran through it over the days, people stopped by to take a souvenir. Some of those artifacts have resurfaced and now reside at the Tulsa Air and Space Museum, including one set of cast-iron door frames, two of the brass art deco wall sconces, and some of the terra-cotta pieces. The only piece that was officially kept by the airport was the original cornerstone. Behind that cornerstone was a handwritten note (below) left there by Charlie Short. (TASM, courtesy Tulsa Airport Authority.)

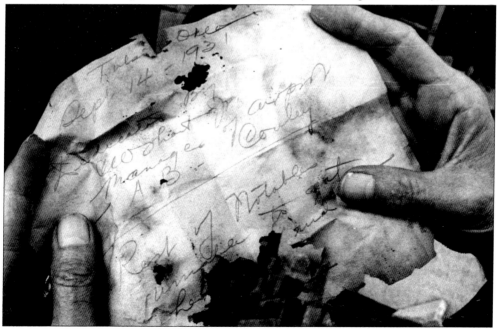

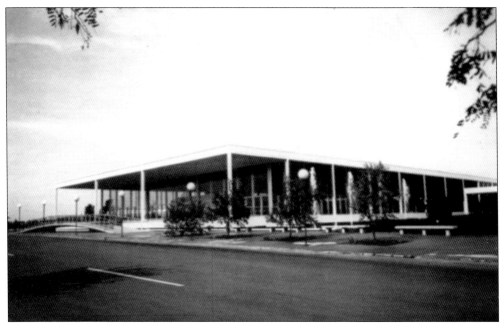

In 1961, Tulsa Municipal Airport opened its new terminal building (above) to replace the art deco terminal that served the airport for three decades. The old terminal was built with the "train depot" idea of loading and unloading aircraft. The new building, designed by Murray-Jones-Murray, was built for the new jet age with concourses for aircraft to taxi to and unload passengers and cargo. The project also included a taller and relocated control tower. The formal dedication was on November 16, 1961. By the late 1970s, the terminal again was feeling cramped, and an expansion was planned that would nearly double the size (below). Included in the project was expansion of the parking facilities and a new entrance road to the terminal. On August 28, 1963, the name was officially changed to Tulsa International Airport. (TASM, courtesy Tulsa Airport Authority.)

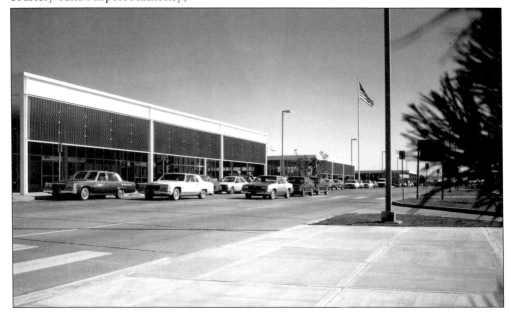

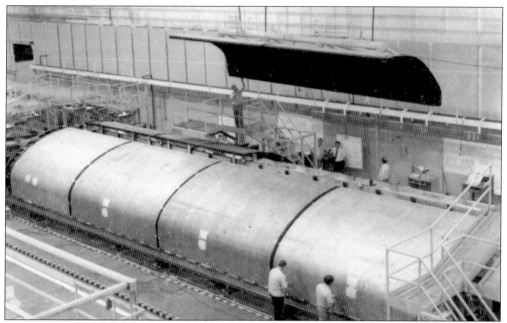

As the Apollo program was winding down, NASA began design and construction of what was officially called the Space Transportation System, or STS. It was also known as the orbiter, but Americans have always called it the space shuttle. Tulsa's Rockwell International received a contract to construct the huge cargo bay doors for the space shuttle program. The photograph above shows the shuttle area inside air force plant No. 3. This jig was known as the strong back and was used to verify the fit and operation of the door sections. One of the cargo bay door sections is hoisted onto the strong back jig (below) with one of the huge overhead hoists. (TASM, courtesy Boeing Company.)

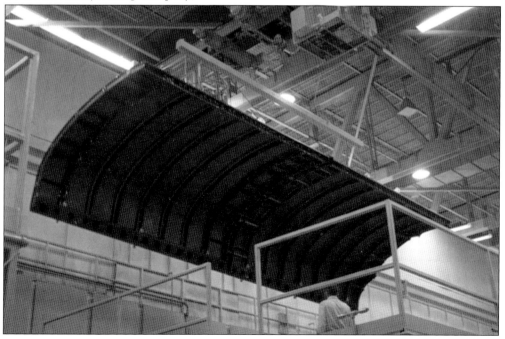

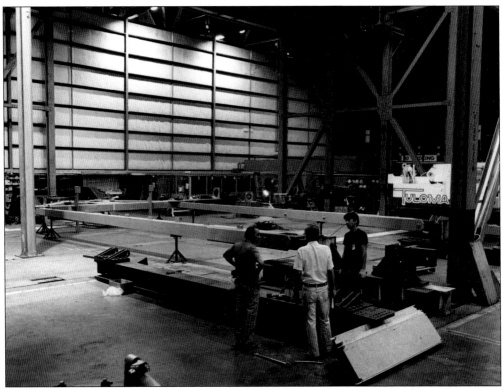

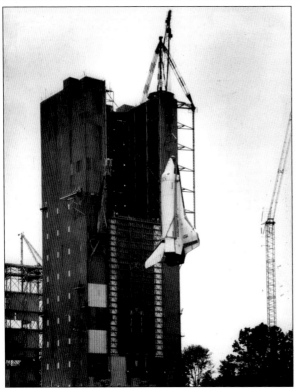

Along with the manufacturing of the cargo bay doors, Rockwell International also built portions of the ground-handling equipment. Since the orbiter lands like an airplane and then must be placed upright for another launch, a lifting device needed to be created. The photograph above shows the large steel jig that was fitted to the orbiter, used to lift it, and then pivoted it vertically to prepare it for launch. Tulsan Francis Burke (left) discusses the lifting jig with fellow workers. Part of the jig can be seen in the background. The jig (left) is used to lift the orbiter vertically and then into place on the launch pad at Cape Canaveral. (TASM, courtesy Francis Burke.)

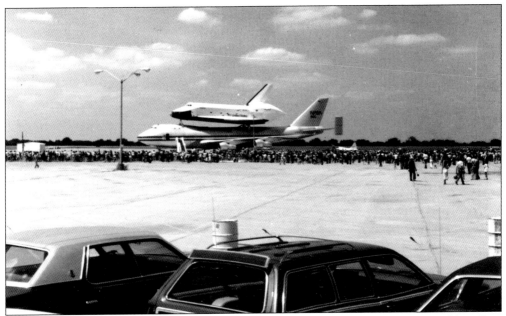

For the work that Rockwell International Tulsa did on the shuttle doors and ground-handling equipment, it was arranged in 1979 for the shuttle *Enterprise* and its 747 carrier aircraft to stop at Tulsa International Airport on its way to Cape Canaveral. Tulsans got a firsthand look at their handiwork on the shuttle. Over 10,000 people viewed the pair of incredible air and spacecraft during the visit. (TASM, courtesy Tulsa Airport Authority.)

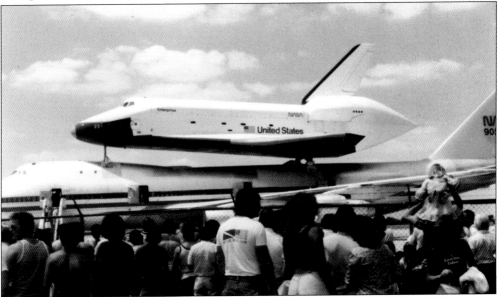

The carrier 747 was a former American Airlines aircraft that was accepted on behalf of NASA at the Tulsa American Airlines maintenance and engineering base. It (tail No. 905) was the first 747 to be converted for shuttle carrier duty. The conversion work was performed in Tulsa, which included stripping of the interior, adding the shuttle-mounting struts, strengthening the fuselage, and adding vertical stabilizers to the horizontal stabilizers. (TASM, courtesy Tulsa Airport Authority.)

On January 15, 1970, the first 747 (above) landed at Tulsa International Airport. It was TWA tail No. N93103. Many local dignitaries were on hand for the event and were treated to tours of the behemoth aircraft. The landing was noteworthy in that it proved that Tulsa International Airport had runways that could support the landing of heavy aircraft. This became particularly crucial for the American Airlines maintenance and engineering base, as more and more jumbo jets arrived for service. The first American Airlines 747 (below) landed for service at the maintenance base in 1969. This particular aircraft, tail No. N743PA, was leased by American Airlines from Pan American Airways. This accounted for the white-painted top, as all American Airlines aircraft are polished aluminum. It is assumed that the aircraft was in Tulsa to complete its transformation to the American Airlines livery. (TASM, courtesy Tulsa Airport Authority.)

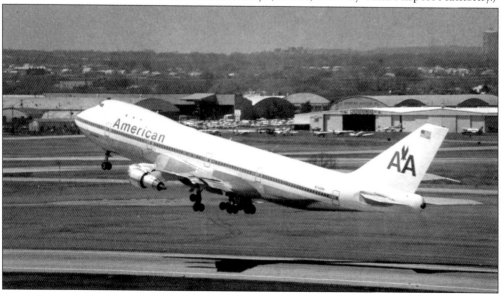

Six

MODIFICATIONS, MAINTENANCE, AND MANUFACTURING

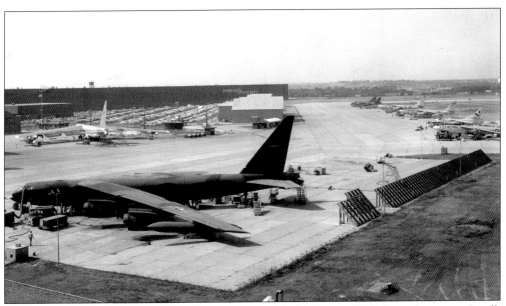

In 1964, Douglas Tulsa received a contract to modify 31 Boeing B-52 Stratofortresses. In all, 117 Superfortresses were completed at the plant. The B-52 was an eight-engine nuclear-capable bomber that was the mainstay of the Strategic Air Command. However, many of the aircraft were fighting in Vietnam in a conventional bombing role. The closest B-52 is painted in the Vietnam-era camouflage of green and brown over black. (TASM, courtesy Boeing Company.)

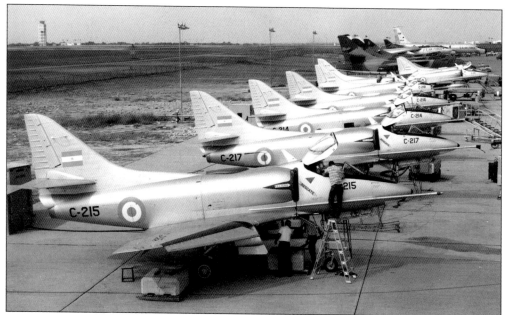

In 1966, Douglas Tulsa received a contract for modification of Douglas A-4 Skyhawks not only for the United States military but also for the Argentinean Air Force and Navy. This photograph shows eight of the Argentine A-4s being prepared for modification. This photograph also illustrates how active Tulsa International Airport was during the 1960s, with a myriad of modification work. (TASM, courtesy Boeing Company.)

A total of 25 Douglas A-4Bs were eventually modified for the Argentinean military. This photograph shows some of the Argentinean Air Force pilots that arrived to test fly the newly modified A-4Bs and accept them for their government's military. It is thought that all the A-4Bs modified in Tulsa were lost in combat during the Falklands War between Argentina and the United Kingdom in 1982. (TASM, courtesy Boeing Company.)

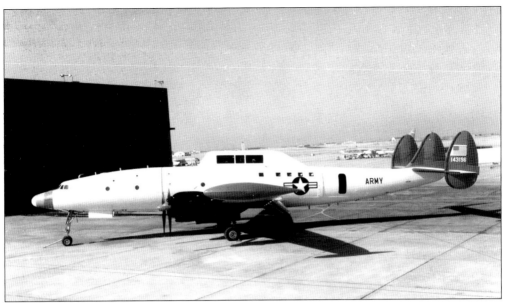

In 1963, Douglas Tulsa received an order for the conversion of the Lockheed Super Constellation into the EC-121 early-warning radar surveillance aircraft. The conversion entailed the reconfiguration of the fuselage to accommodate the newly installed radar and associated electronic equipment. The Constellation first went into service near the end of World War II as the military C-69. This conversion was known to the navy as the WV-2; the air force designation was the EC-121. (TASM, courtesy Boeing Company.)

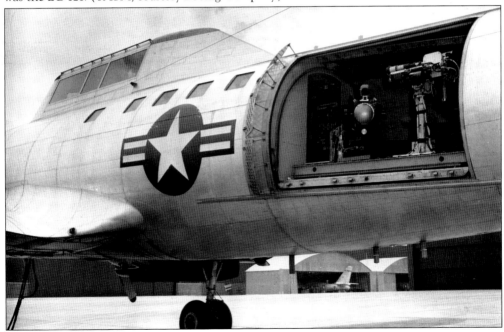

This view inside the port door shows part of the electronic radar and surveillance equipment inside the EC-121. It gives an idea of how sophisticated the conversion was for the day. It shows to good advantage the large bay windows installed in the fuselage and the characteristic hump on the back of the aircraft. (TASM, courtesy Boeing Company.)

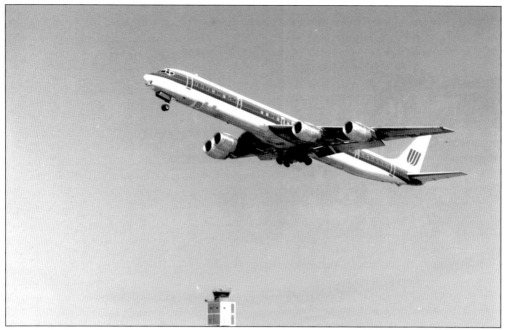

Douglas Tulsa took on a huge program to build parts for the Douglas DC-8, which included the vertical stabilizer and rudder, wingtips, elevators, ailerons, flaps, fuselage sections, cargo doors, landing gear doors, and wing-leading edges. This photograph shows a United Airlines DC-8 as it leaves Tulsa International Airport. (TASM, courtesy Boeing Company.)

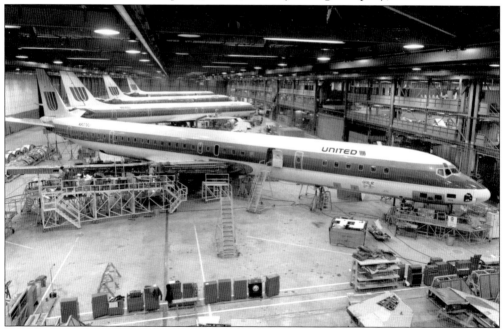

Here is the DC-8 modification line inside Douglas Tulsa. This photograph shows some of the extensive work performed on the wings of the DC-8s as well as the various electronics bays in the nose of the aircraft. Part of the modification included engine upgrade work, but this was undertaken in a different part of the plant. (TASM, courtesy Boeing Company.)

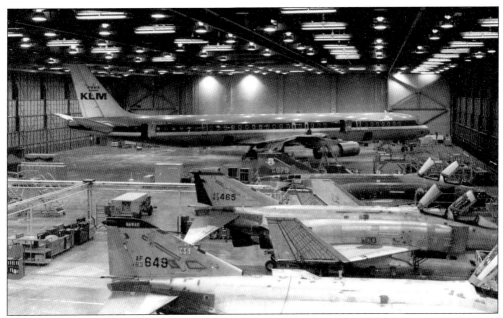

A KLM, or Royal Dutch Airlines, DC-8 undergoes maintenance and modification at Douglas Tulsa. In the foreground is the Douglas F-4 Phantom II modification area. Under the Inspect and Repair As Necessary (IRAN) program, many of the aircraft that were fighting in Vietnam were sent to Douglas Tulsa for repair and modification during the late 1960s and early 1970s. (TASM, courtesy Boeing Company.)

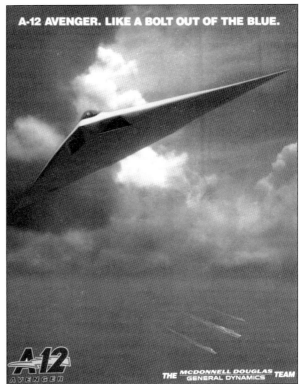

Douglas Tulsa was selected as the final assembly plant for the navy's first stealth technology aircraft. The A-12 was designed to replace the aging Grumman A-6 Intruder. While a full-size wooden mock-up of the A-12 was built, it never went beyond the concept stage. Due to cost overruns, the project was killed before it got started. (TASM, courtesy Boeing Company.)

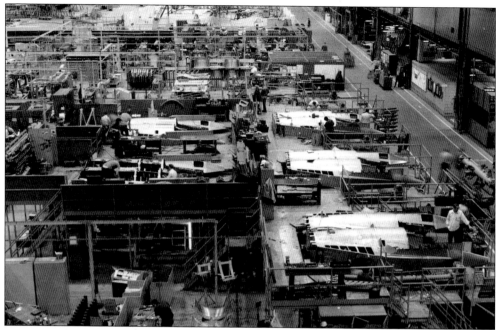

McDonnell Aircraft merged with Douglas Aircraft in 1967, creating McDonnell Douglas. In the early 1970s, the Tulsa division was chosen to build the center section of the new air superiority fighter, the F-15 Eagle. The photograph above shows the F-15 assembly area inside the Tulsa plant. In addition, follow on contracts called for the fabrication of droppable fuel tanks as well as weapons pylon adapters. Another F-15 follow on contract called for the design and construction of low drag, conformal fuel tanks (below). Each tank carries 750 gallons of fuel, thus reducing the need for in-flight refueling. The conformal aspect of the tanks allows all hard points on the wing to carry munitions instead of fuel tanks. (TASM, courtesy Boeing Company.)

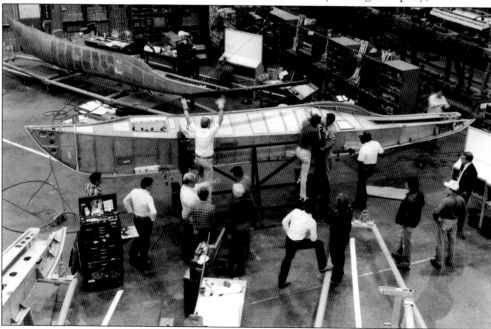

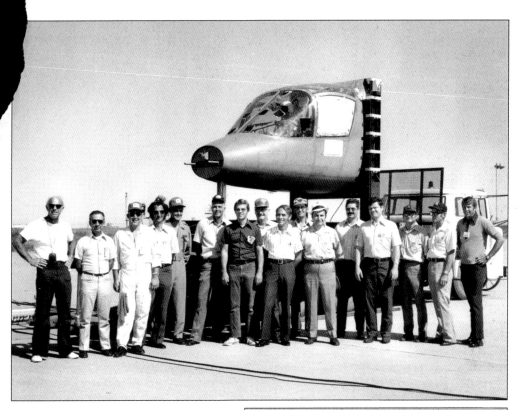

Bell Helicopter contracted with Rockwell International in 1974 to build two prototype fuselage assemblies for its new XV-15 tilt-rotor aircraft (above). One of the most interesting aspects of the project was the ejection seat tests, which required that two pilots could safely eject without hitting the spinning rotors overhead when the aircraft was in the helicopter mode. Anthropomorphic dummies were used to gauge the effectiveness of the ejection sequence (right). The tests were conducted on the ramp near the Rockwell building at Tulsa International Airport. The research performed in Tulsa lead to the creation of the V-22 Osprey that is now in use by the U.S. Marine Corps. The two XV-15 prototypes were flown extensively throughout the 1980s. One of the prototypes now resides in the Smithsonian's National Air and Space Museum Udvar-Hazy facility at Dulles International Airport outside Washington, D.C. (TASM, courtesy Michael Huffman.)

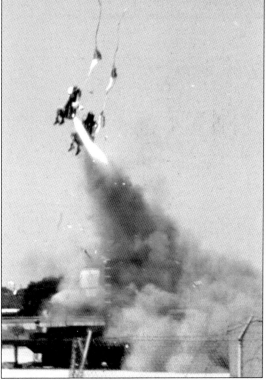

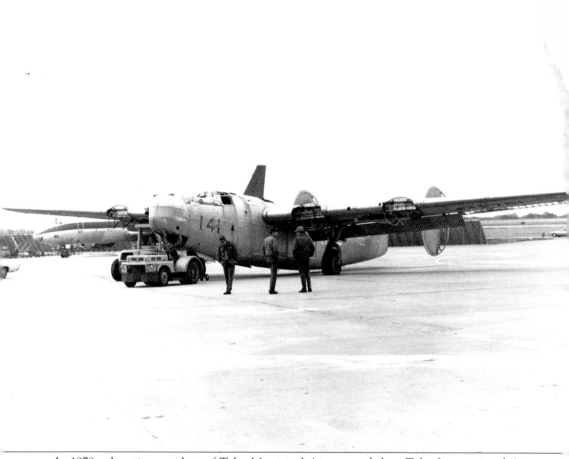

In 1978, a longtime resident of Tulsa Municipal Airport and then Tulsa International Airport flew for the last time. A B-24 Liberator bomber that Spartan School of Aeronautics acquired in 1948 for its students to work on had been traded by Tulsan Marvin Sullenger to the air force for a C-118 (military version DC-6) and two Pratt and Whitney R-2800 engines. The B-24 can be seen in the aerial photograph of the airport on page 87 sitting by the Spartan engine test cells. It was moved in the 1960s to a location near air force plant No. 3. After decades of abuse and neglect, the aircraft came to the attention of the air force. The air force wanted to use it as a "gate guard" at Barksdale Air Force Base in Shreveport, Louisiana. After the deal was struck, the air force flew in a Sikorsky Sky Crane helicopter to lift and fly the old warrior on its last flight to Shreveport. (TASM, courtesy Marvin Sullenger Jr.)

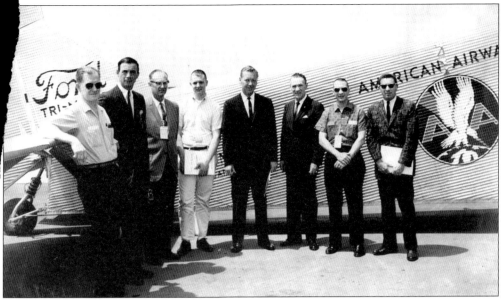

In 1960, American Airlines acquired a former S.A.F.E.Way Airlines Ford Trimotor, NC9683, to restore for promotional purposes. It was brought to the Tulsa American Airlines maintenance and engineering base for restoration. It was restored, mostly through volunteer American employees. The aircraft was flown on promotional tours by American Airlines until it was donated to the National Air and Space Museum, where it now hangs in the Air Transport Gallery. The view above of the Ford Trimotor shows local Tulsa newsmen and airport officials posing for a final photograph with the tin goose. American Airlines employees again volunteered for a restoration project in 1991 (below). The DC-3 *Flagship Knoxville* was acquired by American Airlines to be restored for exhibit at the C.R. Smith Museum at Dallas/Fort Worth International Airport. Over 250 volunteers took on the project, and by 1993, they invested over 12,000 man-hours in the restoration. (Above, TASM, courtesy Tulsa Airport Authority; below, Steve Lederman.)

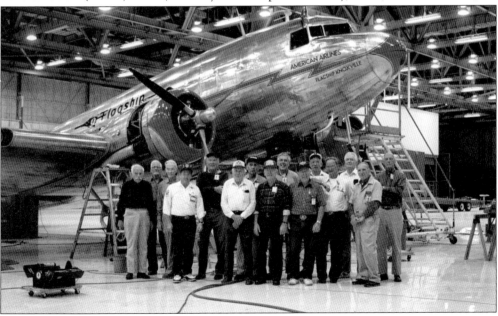

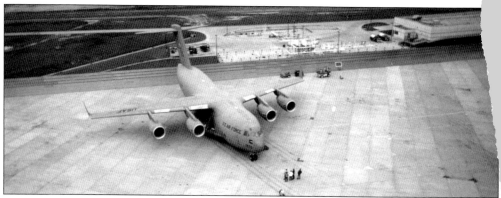

In late 1993, McDonnell Douglas (soon to be called Boeing) leased space from the American Airlines maintenance and engineering base to perform modifications and upgrades on the air force's C-17 Globemaster III cargo aircraft. The creation of what became known as the Boeing C-17 modification center helped to save the C-17 program that was in jeopardy of being canceled. A C-17 (above) is seen on the ramp at the American Airlines maintenance and engineering base awaiting modification. Below, the C-17 modification team poses in front of one of the huge C-17 Globemaster IIIs. For the first time in McDonnell Douglas history, the team was awarded back-to-back Silver Eagle team awards in 1995 and 1996 for outstanding performance in providing the air force with products and services of the highest quality at the lowest cost. (TASM, courtesy John Epperson.)

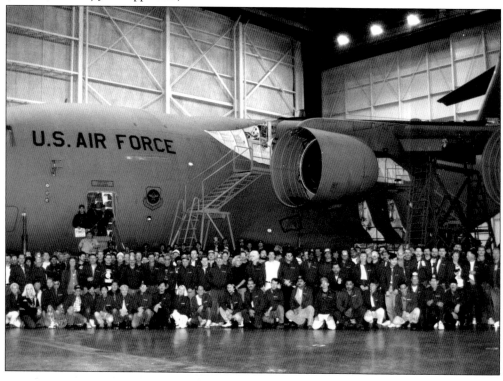

The Hawker Siddeley Company developed the Vertical Take Off and Landing (VTOL) Harrier in the late 1960s. Primary use for the aircraft was for the British Royal Navy so that it could build smaller jump carriers rather than full-size aircraft carriers that were so much more costly. By the 1980s, McDonnell Douglas began building the aircraft jointly with British Aerospace, and it became known as the AV-8. The program was developed to fill a need for the U.S. Marine Corps for a light ground-attack aircraft. McDonnell Douglas in Tulsa was responsible for manufacturing the weapons pylons (above) and the expendable fuel tank (below). (TASM, courtesy Boeing Company.)

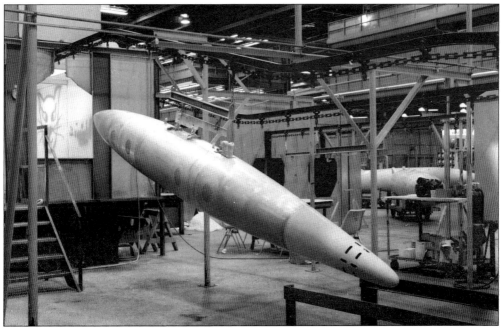

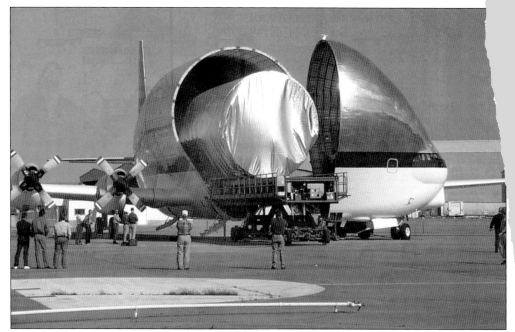

All the former companies that operated in air force plant No. 3, including Douglas, McDonnell Douglas, North American, North American Rockwell, and portions of Rockwell International, became Boeing by the 1990s. Boeing Tulsa received orders for large portions of NASA's International Space Station (ISS), including 11 of the large truss structures that connected the various pieces of the ISS. The Super Guppy (above) receives the P3 truss structure for the ISS. The Integrated Electrical Assemblies, or IEAs (below), framework was literally milled out of a giant block of aluminum alloy. The IEAs kept the giant solar panels oriented toward the sun to supply electrical power to the ISS. (TASM, courtesy Boeing Company.)

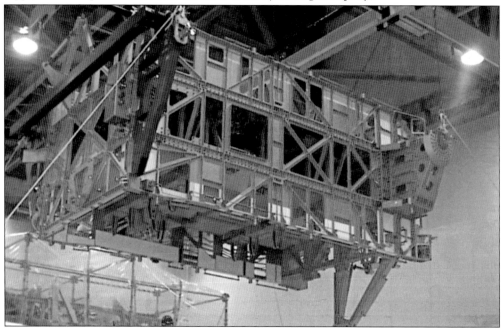

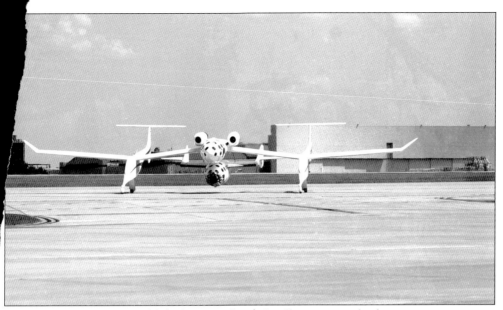

The Ansari X Prize was established to provide a $10 million prize to the first private company to fly a manned spacecraft to an altitude of 328,000 feet twice within a 14-day period. While several small companies vied for the prize, Burt Rutan's Scaled Composites flew its *SpaceShipOne* to win the prize on October 4, 2004. In 2005, *SpaceShipOne* was flown to AirVenture in Oshkosh, Wisconsin, cradled underneath the carrier aircraft known as the *White Knight*. Once it left Oshkosh, *SpaceShipOne* was flown to the National Air and Space Museum in Washington, D.C. While on the way to AirVenture, the *White Knight* and *SpaceShipOne* stopped for fuel at United States Aviation at Tulsa International Airport. Above, the *White Knight* taxis in front of American Airlines. The close-up below shows *SpaceShipOne* underneath the *White Knight*. (TASM, courtesy Ralph Duenas.)

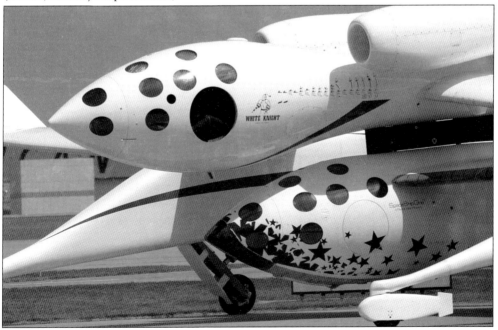

ACROSS AMERICA, PEOPLE ARE DISCOVERING SOMETHING WONDERFUL. *THEIR HERITAGE.*

Arcadia Publishing is the leading local history publisher in the United States. With more than 3,000 titles in print and hundreds of new titles released every year, Arcadia has extensive specialized experience chronicling the history of communities and celebrating America's hidden stories, bringing to life the people, places, and events from the past. To discover the history of other communities across the nation, please visit:

www.arcadiapublishing.com

Customized search tools allow you to find regional history books about the town where you grew up, the cities where your friends and family live, the town where your parents met, or even that retirement spot you've been dreaming about.